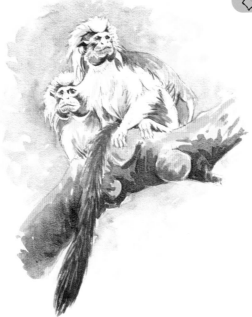

Draw and Sketch
Animals

Sketch with confidence
in 6 steps or less

David Boys

NORTH LIGHT BOOKS
Cincinnati, Ohio

A QUARTO BOOK

Distributed to the trade and art markets
in North America by
North Light Books,
an imprint of F&W Publications, Inc.
4700 East Galbraith Road
Cincinnati, OH 45236
(800) 289-0963

Copyright © 2003 Quarto Inc.

ISBN 1-58180-311-7

QUAR.LDA

Conceived, designed, and produced by
Quarto Publishing plc
The Old Brewery
6 Blundell Street
London N7 9BH

Senior Project Editor: Nadia Naqib
Senior Art Editor: Penny Cobb
Copyeditor: Hazel Harrison
Designer: Tania Field
Photographers: Colin Bowling,
 Paul Forrester
Proofreader: Alice Tyler
Indexer: Pamela Ellis

Art Director: Moira Clinch
Publisher: Piers Spence

Manufactured by
Universal Graphics Pte Ltd., Singapore
Printed by
Star Standard Industries Pte Ltd.,
Singapore

Contents

Introduction

The human race has always had a close relationship with animals, whether those that they hunted or those that worked for them on the land, and they are depicted in many paintings and sculptures from the prehistoric times onward. Sadly, this relationship is now more distant for most people, and our relationship with animals is more superficial—we see wild animals as inhabiting a different world from our own, and can only see them at zoos or watch them through observation windows, telescopes, or binoculars.

But even so, a glimpse into their world fills us with a sense of wonderment and awe. I personally felt this at an early age, and found that drawing and painting was the best way to express my feelings.

Although I have to admit that animals are not the easiest of subjects, I do urge you not to rely too much on photographs—these can be useful, but are no substitute for the intimate knowledge gained through drawing.

When people see me observing and sketching at the London Zoo, they sometimes ask me why I don't just take a photograph and work from that. But although I do use a camera on occasions, I find that photographs are much less satisfactory than drawing. They either provide too much information or not enough, and they freeze action, recording only a fraction of a second in one movement.

As you practice, you will quickly discover the sheer pleasure of drawing, and feel a surge of excitement when everything begins to come together and you find you have captured a true sense of life and movement. I hope that this book will provide some inspiration and an impetus to get you started on this fascinating subject.

David Boys

Materials for projects

Below is a list of the materials you will need for each project. Use good-quality drawing paper unless otherwise stated.

Note that colored pencils and pastels, in particular, are available in a vast range of colors and the names vary considerably from one manufacturer to another. For this reason, pastels and pencils are listed as generic colors (blue, green, for example) rather than as specific manufacturer's shades. Choose the colors from your preferred range that seem to match the ones in the projects most closely.

The size of the brush you use will depend on your own personal taste and on the scale of the drawing you're producing. Brush sizes are therefore given as "small" or "medium," to give you a general guideline about what to select.

But don't worry if you don't have exactly the right equipment at hand: these projects are merely a stepping stone to help you develop your own ways of interpreting landscapes and, as always in art, keen observation is the key to success.

DOMESTIC ANIMALS • 2B pencil • Craft knife

CRANES • Blue-gray pastel paper • Colored pencils: black and white

CAMELS • Blue-gray pastel paper • Conté pencils: sanguine, sepia, and white

PELICANS • HB, 2B, 3B, 5B, 6B pencils • 9B graphite sticks • Kneadable putty eraser • Ordinary eraser

LEOPARD • 2B, 3B, 8B, 9B pencils • 6B and 9B graphite sticks • Kneadable putty eraser • Ordinary eraser

PONIES • Conté pencils: black, brown, white • Conté sticks: black, dark brown, purple, red, red-brown • Craft knife

MANX CAT • Beige pastel paper • 4B pencil • Conté sticks: sepia, brown, black, and white

PENGUINS • Watercolor paper • 2B pencil • Watercolor paints: Cobalt Blue, French Ultramarine, Light Red, Payne's Gray, Yellow Ochre

COTTON-TOP TAMARINS • Cold-pressed watercolor paper • 2B pencil • Sable/synthetic medium and large brushes • Watercolor paints: Burnt Umber, Cobalt Blue, Light Red, Light Yellow, Payne's Gray, Raw Sienna, Ultramarine Blue

BLACK-CHEEKED LOVEBIRDS • Cold-pressed watercolor paper • 2B and 4B pencils • Sable/synthetic medium and large brushes • Watercolor paints: Alizarin Crimson, Burnt Sienna, Cobalt Blue, Cobalt Green, Naples Yellow, Raw Sienna, Scarlet Lake, Ultramarine Blue, Winsor Lemon

VERVET MONKEYS • Hot-pressed watercolor paper • 3B pencil • Charcoal stick • Watercolor paints: Antwerp Blue, Burnt Sienna, Hooker's Green, Lemon Yellow, Payne's Gray, Brown Madder, Raw Umber, Cobalt Blue, Manganese Blue • Sable medium and large brushes

SEABIRD COLONY • Rough watercolor paper • 4B pencil • Watercolor paints: Aureolin Yellow, Cobalt Blue, Light Red, Ultramarine Blue, Yellow Ochre • Sable medium and large brushes

FALLOW DEER • Buff-tinted pastel paper • Colored pencils: brown, gray, green, red, violet, white, yellow

BIRDS IN FLIGHT • 4B pencil • Watercolor paints: Cerulean Blue, Cobalt Blue, Light Red • Sable medium and large brushes

GIRAFFES • Brown pastel paper • Charcoal stick • Colored pastels: blue, green, red, orange, white, yellow

PORTRAIT OF A PET DOG • Beige pastel paper • 4B pencil • Colored pastels: blue, brown, gray, orange, red, white, yellow • Black Conté crayon stick

PORTRAIT OF A PET HAMSTER • B, 2B, HB, and 4B pencils • Putty eraser

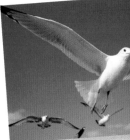

THE FUNDAMENTALS

Getting started

Although animals are not intrinsically harder to draw than any other subject, they do present a number of special challenges. Firstly, they seldom remain still for long enough for you to study them in depth, and secondly, they are usually covered in hair, fur, or feathers, sometimes with eye-catching surface pattern, which makes it difficult to understand the forms beneath. So the best way to start is by observing—familiarity with your subject is a vital step toward drawing with confidence.

Drawing familiar animals

Rather than immediately rushing to a zoo, it is best to begin with creatures that are constantly around you or those you have easy access to. Domestic pets, such as cats, dogs, rabbits, even fish or caged birds, are good starting points, and if you live in the countryside you may find horses, sheep, or cows make rewarding subjects. Horses and cattle both have the advantage of being short-haired, making it relatively easy to see the main shapes. Also, drawing farm animals will give you the opportunity to sketch groups of creatures in their natural context, as well as to make individual studies. Wherever you choose to begin, it is a good idea to keep a sketchbook always handy, making regular sketches of particular postures and behavioral antics at odd moments when time allows.

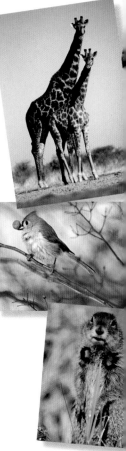

Zoos and wildlife parks

Once you have gained some confidence, you could consider trying out your skills on more exotic animals. Zoos provide a vast range of subject matter, and although the animals are not always in an ideal background setting, they are still affected by light and atmosphere, which are important factors in giving your drawings a sense of reality. And a major advantage is that because the creatures are in a controlled situation, you know that they will be there the following day so that you can continue where you left off. This is far from the case with animals in the wild, which you may not see for long enough to draw. In such cases you will have to rely on a combination of memory and quick scribbles, but the most important thing is to see them as part of their natural environment, affected by and interacting with nature.

Other worlds
A visit to your local zoo can afford you the opportunity to sketch animals that are more commonly found in distant climes. Don't rule out the seashore or your nearest woodland for the endless opportunities these also present.

Familiar subjects
When you start to sketch animals, begin by observing animals that are part of your immediate environment or within easy access of where you live.

Making your first drawings

When drawing on location, keep your materials and equipment to a minimum, as it is not helpful to be burdened with unnecessary gear. You also need to be ready for action, so instead of packing your materials away in a bag, have a few

pens, pencils, or crayons in a handy pocket, and carry your sketchbook; otherwise you could miss a perfect opportunity which might never be repeated. Work as fast as you can—it is better to react with marks on the paper and leave the thinking until later. Keep yourself comfortable and warm so that you can concentrate completely on the task at hand without cold or discomfort. A flask of a hot beverage can be a wise precaution in winter weather.

You must accept from the outset that almost all your subjects will move, so don't take the easy way out and start with a creature asleep in a corner—you will soon become bored with this. Instead, choose animals that offer a variety of activities and poses. Try to identify the simple forms without being distracted by elaborate surface pattern and textures—nature's camouflage to protect the creature from its enemies. Don't be discouraged if your early attempts are less good than you hoped—if you can persevere and get to know your subject well, you will in time be able to draw with confidence.

Form and texture
When starting to sketch, concentrate on an animal's form instead of its surface pattern. But don't let this take away from your awareness of the sheer variety of textures and colors to be found in the animal kingdom.

Sow and piglets
A visit to your local farm can reap many dividends. This tender study of a sow and her piglets was sketched in pencil while the animals were sound asleep.

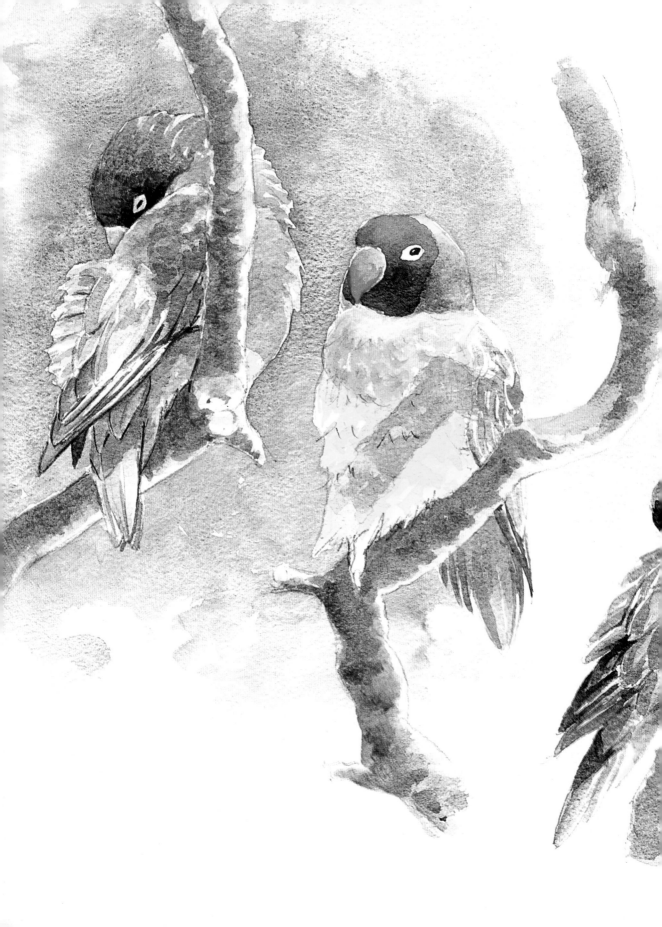

The **Fundamentals**

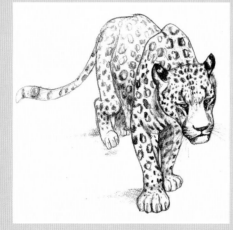

This section of the book outlines the basic principles and techniques that are fundamental to drawing and sketching. The section is divided into subject areas such as Learning to Observe or Drawing with Color, and the information is conveyed through simple step-by-step exercises.

THE FUNDAMENTALS
Learning to observe

Initial attempts at animal drawings can often be frustrating, involving a great deal of erasing and rethinking. This is almost always the result of unfamiliarity with an animal's form and details, but don't worry about it. Drawing is a way of learning to see, and the more you do it the more you will understand your chosen subject.

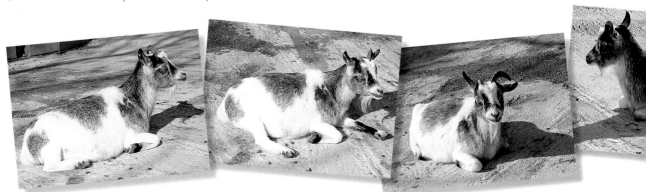

Essential elements

At first, try to identify the basic elements that will go a long way toward describing the creature's shape, character, and movements. Whatever the posture, all the parts are related to each other—the body is held at a certain angle because the head is twisting around, and this in turn affects the balance of the whole body. Everything is dependent on everything else. Thus the first few lines in your drawing should capture the gist of the "pose."

You will undoubtedly begin with a few tentative, half-started attempts, but don't try to erase these, because however crude they appear they will be true to what you have seen. Even if you are less than happy with the results, try to regard them as part of a learning process, in which you build up your knowledge of the subject, just as though you were learning the alphabet for the first time.

Bird in fragments
Birds can be reduced quite easily to a head, body, neck, and feet. Practice sketching a bird in different positions until you get a feel for its body shape.

Look and see
Before you start sketching spend some time simply observing an animal as it shifts from one position to another. Note, too, the way it looks different depending on the direction from which light is coming.

Making multiple sketches

As your chosen subject moves into another interesting pose, sketch this in on the same page rather than starting another one, and don't go back to unfinished drawings and try to finish them. The page will comprise many fragments by the time you have finished, but this will give a better sense of movement and a more complete picture of the animal than many different and unconnected studies on separate sheets of paper.

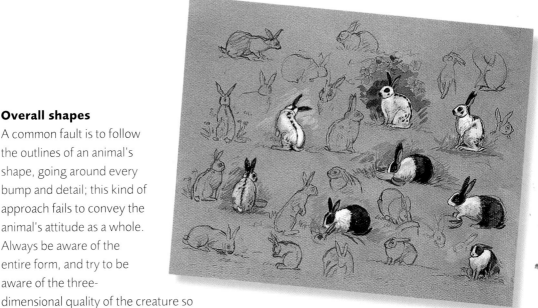

Overall shapes

A common fault is to follow the outlines of an animal's shape, going around every bump and detail; this kind of approach fails to convey the animal's attitude as a whole. Always be aware of the entire form, and try to be aware of the three-dimensional quality of the creature so that you can draw the whole volume and mass. Just like a sculptor, who starts with a wire frame and then adds clay to build up the mass, you need to begin with a basic structure and then add any relevant detail.

The backbone and bulk of the abdomen are good central features to start with, as all other parts extend from these. Imagine the abdomen as a large egg or cylinder suspended in space by wire limbs, and concentrate on this image, analyzing the directional axis and line of balance before engaging with the head and limbs. Look for the way the weight is distributed, and what this does to the animal's anatomy, such as putting stress on any other parts of the body. These first construction lines are crucial in obtaining the stance and attitude correctly.

Once you have some experience, you will not need to draw them in, but you must always bear them in mind. Indicate where the limbs touch the ground; for example, if all four limbs support the body, mark the pattern they create on the ground.

Multiple sketches
Sketching your intended subject in a variety of different positions on the same sheet will allow you to familiarize yourself with its body shape and movements.

Proportions and measurement *Try to imagine a grid like this between yourself and the animal you are trying to sketch. This will give you a rough idea of the relative distances between different parts of its body.*

Basic shapes
Once you have decided your subject's basic outline, you can render the parts of the body—neck, head, limbs, and so on—as simple geometric shapes such as blocks, cylinders, and cones. Your drawing will now begin to appear more three-dimensional.

Checking and measuring

Once you begin to draw, you will need some system for measuring proportions and shapes. Because animals are always on the move, it is difficult to use the standard pencil and thumb measuring method, so you will have to rely on instinct. To help visualize proportions, the overall shape can be divided into an imaginary grid, and positive shapes can be confirmed by checking any negative ones, such as the spaces between legs and so on (see page 72).

EXERCISE I

Domestic animals
by Sandra Fernandez

Drawing animals that are constantly in movement can be daunting. Since the shapes alter as the creatures change position, you don't always have much opportunity to analyze the basic structures. Farm animals, however, do often remain fairly still, as much of their time is spent grazing or sometimes dozing, so they present less of a problem than wild creatures. Before starting to draw, watch the animals, looking for the main shapes and the characteristic patterns of movement, and then begin by drawing connecting parts, such as an ear, the side of the face and the front leg. Don't try to complete the study or erase mistakes, and when the animal moves, begin again.

> **Practice points**
> - LEARNING THROUGH DRAWING
> - MAKING MULTIPLE SKETCHES
> - LOOKING FOR INTERESTING DETAILS

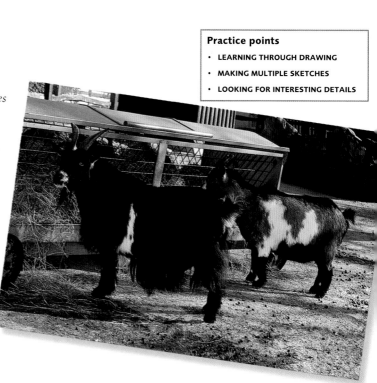

Goats

STAGE I
TENTATIVE BEGINNINGS

■ The first few sketches show a process of learning, in which each attempt is gradually adding more information to your store of knowledge. Drawing anything teaches you to look carefully and discover how to use line to convey the essentials of the subject. As your understanding of the subject increases, your sketches will become more resolved and confident, so stay focused and persevere. Try to work quickly and instinctively, using a sheet of paper or sketchbook that is large enough to accommodate several studies, and don't try to return to a sketch and polish it—a page of half-finished studies creates a more complete portrait of the animal than a carefully rendered individual drawing.

As an alternative to pencil, try using a pen with ink, even a ballpoint, felt-tip, or fountain pen. You may find that you draw with more confidence if you know you cannot erase.

Soft pencils (2B or 4B) produce smooth, flowing lines and are ideal to begin with. Have several pencils sharpened and ready for use, so that you can continue drawing even if one becomes blunt or broken.

STAGE 2

GATHERING KNOWLEDGE

■ The more you draw, the more you will learn, about both the subject and the drawing process. These recorded fragments of information build up your knowledge and help to train your memory, allowing you to create the next drawing with more confidence.

An overall feeling of shape and posture is sometimes more important than being very exact with proportions and detail.

Fragments and disjointed details are all steps toward understanding the animal as a whole.

The pages fill with odd jottings as you gather information. Don't treat these sketches too preciously; they are visual notes to help you to learn.

Don't be tempted to try to invent the rest of a shape to complete it. If this is all that you saw at the time, leave it and move on to the next study.

Look at the form of the animal and the outline of the shape. Shadows describing form can be indicated with just a few crosshatched lines.

STAGE 3

NO INFORMATION IS SURPLUS

■ When trying to capture your subject on paper there seems to be no end to the information that presents itself, and you can never have too much. So if you have the stamina and concentration, fill as many sheets of paper as you need.

Sows and piglets

STAGE 1
TAKING RISKS

■ The piglets produce so much activity that it is hard to know where to start, so be prepared to take risks and make a lot of mistakes. Once you have made a few rough lines to dispel the daunting look of the clean white paper you will find that your drawing hand is reacting as quickly and excitedly as the piglets themselves.

A group of animals together form one basic shape, and can be treated as such, with details such as ears and tails lightly suggested.

As the animals rest for longer periods, you will be able to retain more information, allowing your sketches to become more resolved.

While the animals are constantly on the move, you will need to content yourself with just a few lines outlining basic shapes.

STAGE 2
CONTRASTING SHAPES

■ The arrival of the sow gives you an opportunity to exploit the contrast of size between the adult and the youngsters. You may also see interesting behavioral activity between piglets and sow—for example, the litter starting to suckle from their mother. Capture these often fleeting moments by rapidly scribbling down as much information as possible to create a summary of what is happening at one given moment.

Look for humor and activity to add excitement and interest to your drawings, as well as interesting juxtapositions of shapes such as one piglet against another.

Preliminary warm-up sketches help the eye-brain-hand coordination to "click into gear," enabling you to react quickly when something of interest occurs.

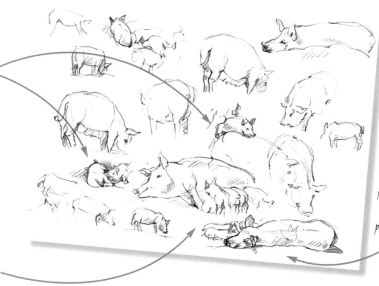

Never be content with just one viewpoint—be prepared to move to a better vantage point if necessary.

STAGE 3
FOCUSING IN

■ When the excitement of feeding time dies down, and the animals are sleepy and content, there is time to study the shapes and forms more closely and look at specific detail. You could also bring some background elements into your sketches to suggest a context for the animals. This is important if you intend to work your sketches up into more finished drawings, as it is difficult to add a background later.

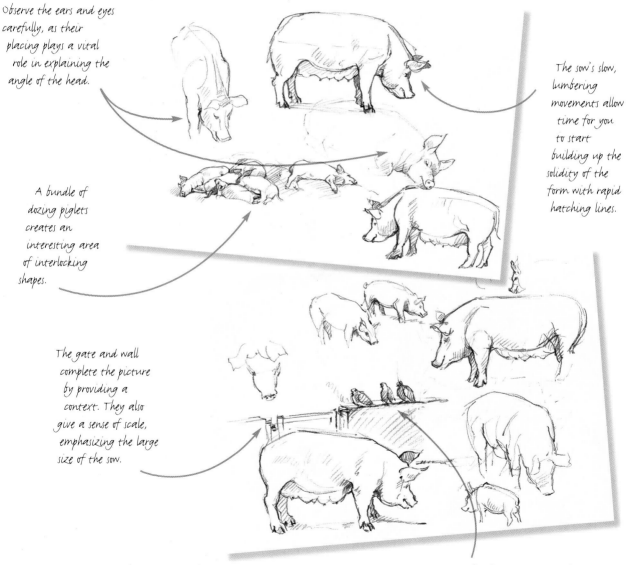

Observe the ears and eyes carefully, as their placing plays a vital role in explaining the angle of the head.

The sow's slow, lumbering movements allow time for you to start building up the solidity of the form with rapid hatching lines.

A bundle of dozing piglets creates an interesting area of interlocking shapes.

The gate and wall complete the picture by providing a context. They also give a sense of scale, emphasizing the large size of the sow.

Keep on the alert for additional features that will add interest and a touch of humor to your drawing.

EXERCISE 2

Cranes by David Boys

Cranes are simple yet elegant forms, often poised on one center of balance, which makes it easy to see the structure and express it as a linear outline. The artist does not simply "trace" the outlines of the subject, however; his lines aim to capture the attitude and posture, as well as to give an idea of how the bird moves. The ability to see beyond the complex external appearance and visualize the inner form as a basic shape is a fundamental requirement for drawing any living subject, so if time allows, spend time watching your subject, and you will begin to identify certain shapes, postures, and stances.

Practice points
- IDENTIFYING THE MAIN SHAPES
- TAKING VISUAL MEASUREMENTS
- GIVING A SENSE OF BALANCE

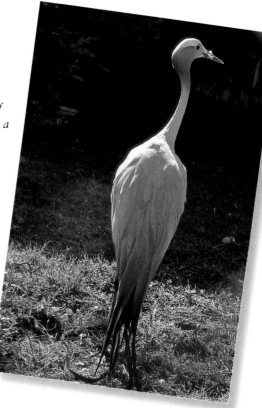

STAGE 1

THE CENTRAL MASS

■ Because a great deal of visual information is presented to you when you are drawing from life, it can be difficult to decide where to begin, but in general the bulk of the body is the best starting point, as all the other components extend from this. In the case of this bird, the body can be visualized as a simple egg shape. Normally the artist would develop each sketch to a more finished stage before beginning another, but for this demonstration he has pre-planned several shapes showing different stances and angles.

Consider the placement of your shapes within the page boundaries, allowing space for your drawing to grow.

To help identify the angle of the egg shape you may find it helpful to draw in a directional axis line.

STAGE 2
SUPPORTING THE MASS

■ The main bulk of the bird is some distance above the ground, supported by the long, thin legs. It is important to get the proportions right in the early stages of the drawing, so make a visual check of the proportions of body to legs, and the distance between various strategic points. If the bird remains relatively still, you can take physical measurements by holding up your pencil and sliding your thumb up and down it.

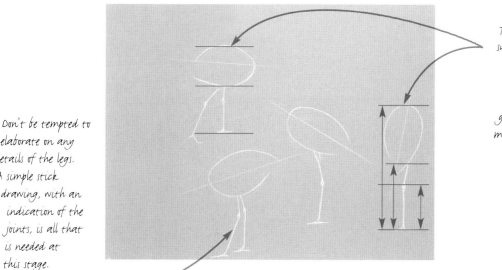

Until you become familiar with your subject and confident in your drawing, it is useful to make marks on the paper as guidelines for various measurements.

Don't be tempted to elaborate on any details of the legs. A simple stick drawing, with an indication of the joints, is all that is needed at this stage.

You can use your pencil to compare the length of one part of an animal's body with another. Concentrate on your subject then hold the pencil vertically out in front of you on an outstretched arm, and move your thumb to mark different lengths.

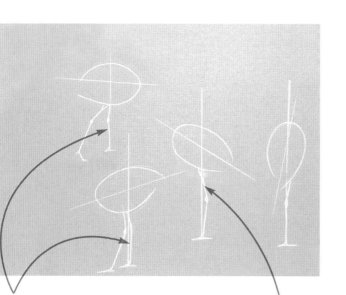

STAGE 3
POINT OF BALANCE

■ However correct the proportions, your drawings will not be convincing unless you show how the weight is distributed. An animal might be resting its weight on all four legs, or on three, while this bird will rest mainly on one leg. The way you position the legs to convey this sense of balance is vital to the whole structure of your drawing, so look carefully to identify the balance line.

Even though both legs are visible, one is supporting more of the weight than the other, so this is where the balance line is placed.

The balance line runs vertically upward through the body from the point of contact with the ground. Draw this line as one of the first stages of the sketch.

STAGE 4
THE MOVING HEAD

■ As you will quickly discover, the head and neck are in almost constant movement, changing the shapes and angles from second to second. Rather than trying to keep up with these changes, you will need to make a decision, fixing the components in your mind and continuing with the shape that you feel is right for the rest of the drawing.

Visualize the head as a simple egg shape and fix its position in relation to the rest of the body. The neck dictates the angle of the head and its distance from the body.

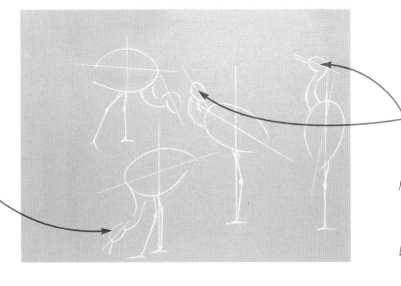

You may find it helpful to draw in a directional axis line to establish the angle of the head. If you fix its position in relation to the rest of the drawing, you will be less confused by later changes in position.

STAGE 5
COUNTERBALANCE

■ The shape will be incomplete until the form of the "tail" is indicated. This bulky shape is not in fact the true tail, which is hidden beneath; it consists of extended secondary feathers from the bird's wings. These feathers appear to have developed through the process of evolution so that they act as a counterweight to the head and neck as well as being used for display purposes. They are a characteristic feature of cranes, and drawings made when the birds are molting look strangely unbalanced and lacking in rhythm.

There is no need to dwell on detail; an indication of the direction and forms of the feathers is sufficient.

Completing the form with the tail feathers sets up a rhythm through the whole of the body, head and neck.

Seen from the back, the feathers can be simplified into an elongated triangle.

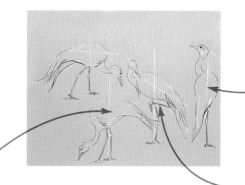

Notice how the whole of the bird's shape and posture can be captured with just a few well-placed lines.

The white crayon lines would not normally be part of the artist's drawings; they are intended only to explain the construction process.

Drawing demands constant honing of your acute senses to allow the essential flowing lines to develop on the page in a meaningful way.

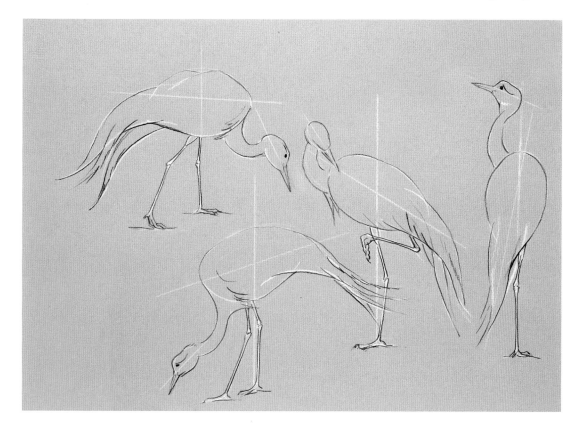

STAGE 6
THE CONSTRUCION PROCESS

■ All the artist's sketches that deal with form and movement go through a similar construction process as that shown on these pages. As you gain experience, you will use similar processes instinctively and will rely less on the thought process as you draw your lines. Artists often talk about "getting their eye in," a phrase that describes the development of the eye-hand-brain co-ordination that is essential to good drawing.

EXERCISE 3

Camels by David Boys

In contrast to the elegant cranes drawn on pages 16–19, these Bactrian camels have an ungainly appearance, their twin humps appearing to be a cumbersome burden that makes the creature sway awkwardly as it moves. But the humps are the animal's lifeline, containing a store of fat without which it could not survive in its desert homeland of the Mongolian Steppes. The strong, sculptural shapes of these camels make them fascinating models, and since they don't move very fast you will have more time to study their forms and postures than with the more active creatures. Ideally, you should observe them both in summer and in winter, as they seem almost like two different animals. In winter their thick shaggy mass of hair can disguise their underlying structure, while the summer molting reveals their sleek, muscular forms.

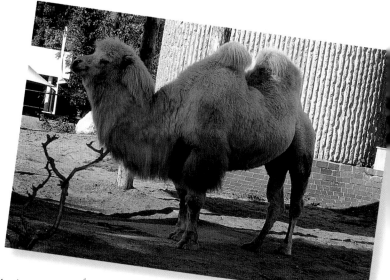

Practice points

- CHECKING SHAPES AND PROPORTIONS
- ENCLOSING FORMS WITH LINE
- BALANCING THE BODY

STAGE 1

THE FIRST LINES

■ The aim is to capture the creatures' overall stance and give an impression of the solid volume of the forms. When starting to draw a living creature you will have to overcome the initial feelings of anxiety caused by not knowing how long the animal will retain its posture. The best approach is to look hard before drawing, and then think about the lines you put down.

These crucial lines set the stance of the animal. Although they appear disjointed and do not follow the outlines, they work in relation to each other to represent the animal as a whole.

A good way to check whether the legs are correctly placed is to mark the pattern made by the feet touching the ground. You can draw in this shape if you find it helpful.

To ensure correct perspective, draw a directional axis line along all the points of contact with the ground.

STAGE 2
CHECKING PROPORTIONS

■ Before you begin to embellish the drawing, it is vital to check that the first lines enclose a set of forms that are in proportion to each other. When working from a moving, living model there is seldom time to use the usual pencil-and-thumb method to work out the measurements, so you may have to rely on quicker visual checks.

One method of checking proportions is to imagine a grid of vertical and horizontal lines superimposed across your subject.
This allows you to measure by checking the divisions of space between the lines.

By looking at negative shapes (see page 72), you can check both proportions and angles. These shapes are easier to identify than those made by solid forms, as there is little distracting detail.

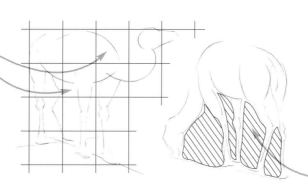

Any other forms that have a relationship with the main subject, such as this background log, should be fixed in the early stages. They may become an important element in the drawing, and it can be difficult to superimpose them later.

To fix the angles and stress points of these rear legs, note the overall shape that they form. This is more important than getting all the details exactly right.

STAGE 3
BALANCING THE BODY

■ You also need to check the distribution of weight, marking in what are known as balance lines or stress lines, before further developing the drawing. Four-legged animals generally have two points of balance for you to consider. Sometimes the weight is distributed equally between the pair of front or rear legs, and sometimes it is carried by only one leg. Look for a rising hip joint or shoulder blade, as this indicates which leg is supporting the weight. To make this clear, the artist had added another sketch showing a different posture.

Hold up a pencil vertically to check stress lines where the animal is bearing most of its weight, and mark them in lightly.

STAGE 4
ENCLOSING VOLUME AND MASS

■ It is easier to build up three-dimensional form when using tone (see pages 34–35), but there are ways of doing this in line. One method is to draw contour lines, rather like those on a map, that follow around the forms. This is sometimes known as bracelet shading, and although it may not be an effect you want to retain as part of your artistic repertoire, it is very useful as part of the learning process, as it forces you to come to grips with the concept of form.

When drawing contour lines, try to avoid thinking too much about the outlines. Imagine you can see through and around your subject and make lines that enclose the volume.

Visualize the forms as simple volumes—cylinders, cones, blocks, and egg shapes.

TIP
When you draw roughly parallel arcs or curves, try to keep the lower part of your hand still on your drawing surface as you make circular movements with your pencil. This affords you more control as well as ensuring that the arcs are parallel.

Sometimes it is useful to use a light-colored medium (in this instance, Conté pencil) for the construction stages, reinforcing the essential lines with a more dominant medium.

STAGE 5
EMPHASIZING THE LINES

■ These sketches are intended mainly as a teaching aid, and show how the artist arrives at a final result through a series of constructional stages. The darker lines represent the actual lines which have been emphasized in order to take the drawing toward completion.

Points of contact with the ground can be emphasized with a few lines suggesting sand, gravel, grass, and so on.

You can build up the forms through rough crosshatching to denote the darker shadows that help to accentuate the forms. You can develop these marks to a more finished stage at a later time.

Once the underlying structure is in place, you can indicate the hairy mane around the camel's neck, using a few decisive directional lines.

Indicate the positions of eyes, nostrils, and ears, and once these are correctly placed you can add refinements, even if the animal changes position.

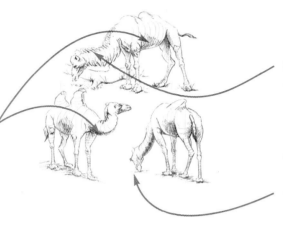

STAGE 6
READY TO DEVELOP

■ A few lines in the right place will have captured the posture, attitude, and stance while also suggesting the forms. Any further details will be embellishments that may be necessary to complete the drawing and provide the artist's personal interpretation of the subject. Always bear in mind that you are not just copying the subject; you are translating what you see into your own artistic language.

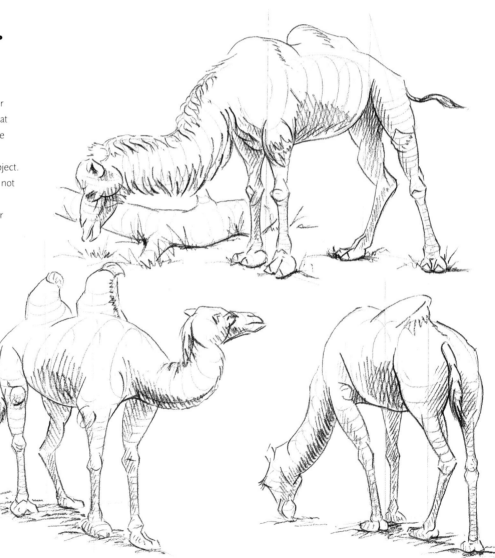

Beyond the externals

Bone structure
Just being aware of the nature of the skeletal structure that lies beneath an animal's outer covering can make it easier to draw it in convincingly and in a wide variety of positions.

Drawing is not a matter of blind copying; it is a dual process of learning the subject and discovering how to translate what you see. The lines you draw should not follow an exact outline; instead they should enclose a volume, and suggest the hidden forms and dynamics of the animal. When you draw, bear in mind that all the lines or marks have a relationship with one another, and should be placed accordingly. A few well-placed lines can suggest more about form and movement than any amount of superfluous detail.

Understanding construction

In order to use line in a meaningful way, it is essential to understand the forms. Although you do not need a degree in anatomy, you should look for ways of becoming familiar with the anatomical construction of animals. Books on natural history can be helpful, and so can museum collections. In some cases these display skeletons of animals and birds, which you can draw to help you to gain understanding. You will see that many animals have a skeletal structure that can be compared to our own, adapted to suit their different ways of life, and it is these adaptations that make each species unique.

Putting it into practice

A knowledge of the capabilities and limitations of various joints and muscles, together with an understanding of the bone structures, is an invaluable aid to analyzing the living forms when sketching from life. For example, to draw birds flying, giving them a sense of buoyancy in the air, it is important to grasp the physics and construction of the wings—and to spend many hours observing. If you know that a bird's beak is hinged well back in the skull, although hidden by skin and feathers, you will be able to draw a wide-open gape more convincingly than if you relied on observation alone. In the same way, you can't see much of a bird's leg structure, as all except the wrist joint and toes is hidden inside its body, but if you have studied a skeleton you will find it easier to draw the bird, making it stand, walk, perch, and take off in a convincing manner.

Feathered friends
Observing the anatomical make-up of birds is particularly interesting—and useful—because we do not instinctively think of them in such specific terms.

Subject and memory *Try to learn about the structure of animals that are familiar to you. The more you see them, the more you will be able to link your observations of their external form with your memory of their internal structure.*

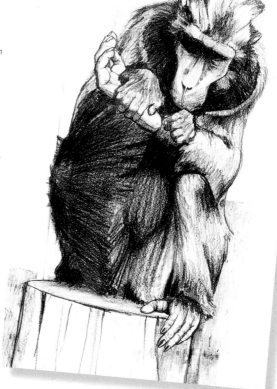

The role of memory

Memory plays a part in nearly all drawing, which is why we find it easier to draw a familiar subject, and it is especially important when you are dealing with a subject in movement. Once you have gained a good understanding of what lies beneath skin, fur, or feathers, you can draw on memory as a backup to first-hand observation. You will find you do this almost unconsciously. So the more you can study, the more confident your drawings will become, and you can begin to exploit the qualities of line that make drawing such an exciting process.

Feeding anteaters
The artist's knowledge of the skeletal structure of these outwardly shapeless and cumbersome anteaters gave him the basis for creating this delightful composition.

Sulawesi crested macaque
When an animal is as hunched as this macaque, it is actually easier to see his knee joints, hand knuckles, and angular facial structure. His skeleton is also more readily comparable to our own.

EXERCISE 4

Pelicans
by Victoria Edwards

Pelicans are large, bulky birds, whose extraordinarily elongated, almost "primitive" features give them a gawky, humorous appearance—until they take flight and are transformed into graceful creatures. To add interest and character to your drawings, good features to observe and exploit are the huge throat pouch and the characteristic slow waddle made with large inward-pointing webbed feet. However, you also need to be aware of the hidden skeletal structure, as this will aid your understanding of the basic body forms. This prior knowledge is especially helpful when drawing the birds in movement, as it allows you to quickly put down a simple but accurate shape.

Practice points
- **LEARNING THROUGH SKETCHING**
- **DIFFERENT WAYS OF APPLYING TONE**
- **DRAWING FEATHERS**

STAGE 1
WARMING UP

■ To build your confidence and begin the process of learning through drawing, start by making a few preparatory sketches, using a medium-soft pencil such as a 2B or 3B. Keep the studies simple and linear, drawing only the few lines that you think will best describe the shapes and postures. Try at this stage to think about the underlying bone structure and how different movements affect it.

Pelicans have very long, curving necks comprising many vertebrae, giving them extreme flexibility for feeding and preening.

The powerful muscles that enable the pelican to fly are attached to the keel on the large breastbone. The lightness of the skeleton facilitates flight—the pelican weighs much less than its size suggests.

The birds walk on their toes, with only the ankles visible. The rest of the leg is hidden by the plumage, but it is helpful to know that the knee joint is positioned as high as the level of the wing bones.

The hinge pivot that connects the lower jaw to the upper is set well back in the skull. The hinge is not visible, but knowing where it is helps you to draw a gaping bill convincingly.

STAGE 2
GAINING EXPERIENCE

■ As you practice and observe, your sketches will begin to improve, with the lines you draw having more visual meaning and the relationships between different parts of the body becoming more convincing. But because a bird's feathers can disguise so much of its anatomical construction, knowledge of where the joints are placed makes it easier to understand the relative sizes and proportions.

While resting, the wings are held close to the body. Notice the length of the wrist and "hand" in comparison with our own.

The large wings are driven by two very long "armbones" and one slightly shorter one.

It is vital to place the basic structural lines before adding any tone or detail.

STAGE 3
REINFORCING THE LINES

■ Once you are happy with the shapes and proportions, you can begin to reinforce some of the lines with bolder pencil marks made with a softer pencil—a 5B or 6B. Be careful not to strengthen lines randomly, for example, lines on the parts farthest away from you should be left light to give a perspective effect. Concentrate on the lines that describe the most prominent parts of the bird's anatomy.

Lightly sketching in feathers to denote form or angles can help you to decide where to add tone, even if you decide to remove or work over these lines at a later stage.

By strengthening the lines where the forms turn away from the light you can begin to suggest volume.

At this stage you can start to indicate the feathers and the forms of the wings with curving directional lines.

STAGE 4
BUILDING UP TONE

■ You can now consider whether you need to add tone in certain places. Think about the direction of the light source, and take care to work only on areas that are truly affected by shadow. In this case the light is coming from above, so there is little or no shadow on the bird's back, head, or the tops of the wings, while the sides of the wings curve away from the light and thus become progressively darker. Wherever possible, use shading lines that serve a dual purpose—suggesting feathers and building up tone at the same time.

A sharp pencil will give crisp lines that add verve to your drawings, so always keep soft pencils well sharpened. It is better to use a blade rather than a pencil-sharpener, as this allows you to make a longer point.

Use a 2B pencil to begin blocking in the more obvious shadows.

The curve of the neck creates a patch of shadow in the middle. Take the opportunity to give a light indication of feathers as well, using a medium pencil such as an HB.

Don't overdo the markings in these areas, or you may weaken the overall tonal contrasts and lose the three-dimensional quality.

With a 6B pencil, draw in more curving lines for the feathers and reinforce existing ones to slightly exaggerate the rounded form of the wing.

For really rich darks, such as the eyes and bills, a 9B graphite stick is ideal. Keep it well sharpened for precise detail.

Dragging the flat side of an eraser lightly across soft pencil lines in the opposite direction can produce even blocks of tone. You can then reclaim highlights on the feathers by lifting out tone with a putty eraser.

You can employ different grades of pencil, from hard to soft, to bring out the subtle markings on the pelican's bill.

STAGE 5
PULLING IT TOGETHER

■ The sketches now require some final tonal adjustments to make them look three-dimensional. You can use a variety of methods to create subtle tonal effects, such as mixing different grades of pencil, using an eraser to spread line, or lifting out with a putty eraser to lighten areas of tone. Depending on the tolerance of the paper you are working on, you can rework each area until you achieve the desired effect.

EXERCISE 5

Leopard
by Victoria Edwards

The leopard is perhaps the most graceful and athletic member of the cat family, and its beauty, strength, and agility make it an exciting and challenging subject to draw. It owes its attributes largely to its extremely flexible skeleton, so it is vital to look beyond the outer "clothing" to understand the underlying anatomical construction. In this exercise, the artist demonstrates how the ability to visualize the skeleton will enable you to plot a simple yet convincing shape and use it as a framework onto which you can add both tone and detail. She is using soft pencils and graphite sticks, and working on fine-grained drawing paper.

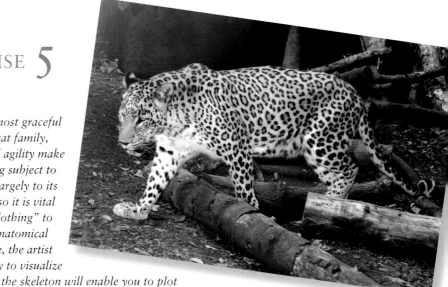

Practice points
- **UNDERSTANDING THE STRUCTURE**
- **USING DIFFERENT GRADES OF PENCIL**
- **BUILDING UP PATTERN AND FORM**

STAGE 1
WARMING UP

■ Using a 2B or 3B pencil, start by making some simple line drawings describing form, attitude, and movement, choosing a variety of poses and drawing from different angles. This will help you to learn the animal's overall shape and observe how the weight of the body is constantly redistributed as it moves. With every pose the leopard assumes, the bone and muscle structure beneath alters position, changing the shapes you see.

When the animal is standing still, the body weight is equally distributed between both shoulder blades, which are clearly visible through the skin and fur.

To allow the leopard to jump long distances, the bones of the hind legs are longer than those of the forelegs, with a thick covering of muscle. The knee joint is hidden by muscle, so try to visualize the skeleton beneath.

When walking, the weight and stress of the body is very noticeable, as the shoulder blade of the weight-bearing leg is pushed up.

Like all members of the cat family, the leopard always walks on its toes. Note where the ankle bone appears on the hind leg.

STAGE 2
HOMING IN

■ Continue to draw as many different poses as possible, always trying to visualize the skeleton and the way its positioning causes the muscles to expand and contract. Tackle a foreshortened view if possible, as in this case the perspective will alter the proportions, something you will have to come to grips with in any subject you draw. This frontal view also gives you an opportunity to study the proportions of the head and the placing of ears, eyes, and nose.

When the animal sits, the thigh bone pushes upward and the leg bends at the knee, changing the shape to a more rounded form. Note how the ankle and foot rests flat on the ground; this cannot be seen in life as it is hidden by the covering of muscle, skin, and fur.

As the left foreleg takes the weight and stress of the body, the right one is moved forward. As the leopard makes its next step, the weight will be transferred to the right shoulder blade.

Knowledge of the relative length of the bones and the placement of the joints can help you achieve the right proportions.

A drawing like this, showing the basic construction lines, provides an excellent basis on which to build up detail.

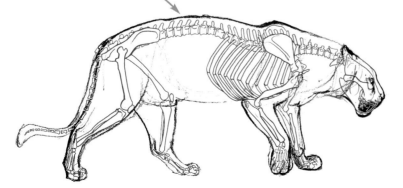

Graphite sticks, like pencils, come in different grades from hard to soft. This 9B stick is ideal for the markings on the coat, as it provides rich dark tones and can be held at a slant to achieve broad marks.

STAGE 3
BUILDING UP TONE AND DETAIL

■ Now that you have drawn the basic construction lines, you can begin to build up the form of the animal with shading, and then concentrate on the markings. To analyze the tones, half-close your eyes so that you can pinpoint the main dark areas, bearing in mind the muscle forms beneath, which will influence the depth of the shadows. Study the markings carefully, as the spots are neither equally distributed nor all the same size.

With a 6B graphite stick, start to plot the leopard's spots and other darker markings, beginning with those around the eyes and mouth and on the tops of the ears.

Build up the forms with different grades of pencil and graphite stick. It is best to build up gradually from midtones to dark tones, using the softest grades when you are sure of the depth of shadow required.

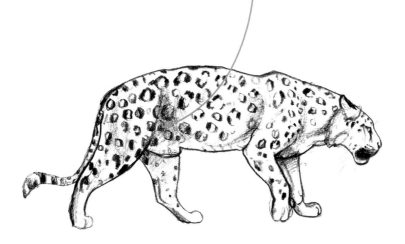

To give a sense of solidity and ensure that the animal doesn't appear to be floating in the air, indicate the cast shadows lightly with a 2B pencil.

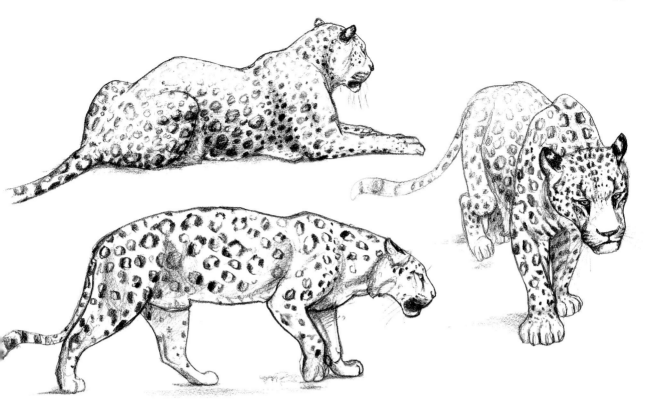

STAGE 4
FINAL ADJUSTMENTS

■ The more depth and contrast you give to the image, the stronger it will be, so in the final stages you may need to adjust the balance of light and dark. When strengthening shadows, however, always consider the basic structure, as misplaced darks can misrepresent the form. You can also use tonal contrast to give a sense of perspective. For example a very soft pencil or graphite stick (8B or 9B) can be used for carefully drawn areas nearest to you, and harder ones for those farther away, which are less clearly seen.

Any areas of the drawing that have become overworked or too dark can be lifted off with a putty eraser, which you can knead into a point.

The tail and hindquarters are farther away, as the animal is seen in perspective, so you can draw these with a harder pencil and treat them in less detail.

Close observation will reveal differences in the pattern of spots on the leopard's body. Those on the flanks and legs appear to be randomly scattered, while those on the head have a vague symmetry, and the spots along the back appear in little groups.

The effect of foreshortening can be enhanced by deepening the tones of the markings on the face and parts of the forelegs, which are closest to you.

THE FUNDAMENTALS

Drawing in tone

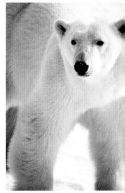

Drawing in line alone has its limitations. Although well-placed lines, varied in thickness, can suggest form, the appearance of mass and solidity is better achieved through the use of tone—light and dark colors. The range of tones, running from black to white through many shades of gray, is almost infinite, so it is usually necessary to simplify or your drawings may become confused and diminished in impact.

Light and tone

First consider the effect that the ambient light has on the subject. In strong sunlight, there will be dark shadows and bright highlights, while in lower levels of light the range of grays is much subtler, indeed it can be hard to distinguish one from another. It is up to you to decide the tonal "key" of your drawing, deciding on the extremes of tone before you begin. To do this, it helps to half-close your eyes, which reduces the range of tones and cuts out much of the unhelpful detail, allowing you to identify the stronger contrasts. A scene is said to be in high key if the average tone is pale, with minimum overall contrast, and in low key if it contains mostly dark tones, with large areas in shadow.

From color to tonal values
Taking a black-and-white photocopy of a color image allows you to see the scene's tonal values more clearly.

Tonal range
The range of tones running from black to white, through many shades of grays is nearly endless.

Tone and local color

One of the difficulties inherent in analyzing tone is that you can be misled by the impact of color and by your own first-hand experience of a creature's color. You know that a swan is white, and it is thus hard to appreciate that the shadows may be a deep gray, or that it may appear as a dark silhouette when seen against a brightly lit background. Similarly, a black swan may appear as light gray against a very dark background. Many animals use this counter-shading to help disguise their forms. For example penguins that "fly" through the water have pale underbellies, helping to reduce their darkened silhouetted forms when viewed by predators or prey from below, and their dark top plumage reduces the reflective light to make them more difficult to see from above. When drawing animals you will notice many have pale underbellies which helps lighten the shadow areas of their forms, and darker coloration on their backs where the light reflects on it.

Plays on white
Don't let your first-hand knowledge of an animal distract you from recording the ways in which its color—especially if it is white— alters in response to its surroundings.

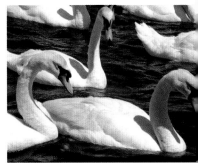

Cast shadows

You can often heighten the three-dimensional feel by using cast shadows, which also help to explain spatial relationships. They may also create interesting shapes and patterns, which can add an extra element to your drawings. Cast shadows vary in density of tone depending both on the lighting conditions and on how close they are to the object that casts them. If you look at an animal resting on the ground in strong light you will see that the cast shadow is darkest directly below the animal, becoming lighter as it spreads out. In very strong light the cast shadow and the shadow of the form itself merge together, making it difficult to distinguish any dividing line.

Cast shadows
In weak light (top) the cast shadows and the shadows on the animals (form shadows) are quite pale. As the light gets stronger (center), and stronger still (above), both form and cast shadows become darker and more defined.

Highlights
Highlights can become lost against a light background. Introducing a darker background makes them stand out more clearly.

Tone and paper color

When you are drawing on white paper, the lightest tones are "reserved," that is, the paper is left white. The rest of the paper then has to be filled in with other tones to allow the highlights to stand out. This is a rather slow way of drawing, so you may find it helpful to work on a midtoned gray or brown paper, which allows you to develop the light and dark tones at the same time. If you use pastels, chalks, or an opaque paint, you can use white or near-white to draw in the highlights, altering them as you choose.

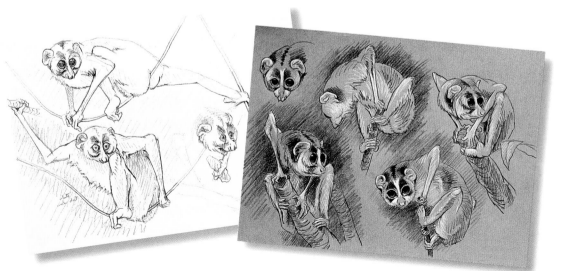

Paper color *When working on white paper (near right) you can only shade in darker and darker areas, reserving the lightest tones as highlights. On midtone paper, however (far right), you can shade in both lighter and darker areas.*

EXERCISE 6

Ponies
by Sandra Fernandez

Horses and ponies, with a few exceptions, are short-haired, making it easier to analyze the underlying forms than it is with long-haired animals or birds, and

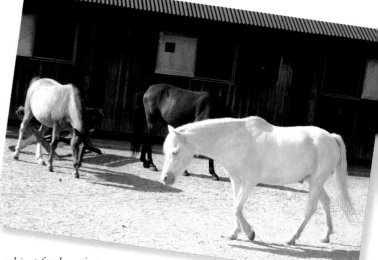

their evenly colored coats have no strong patterns to distract the eye. For these reasons, they provide a good subject for learning to assess tone and for practicing different ways of creating a solid, three-dimensional feeling in your drawings. When standing or grazing in a field, their movements are relatively calm and repetitive, allowing time to observe postures and notice how the play of light explains the forms by creating highlights, midtones, and shadows.

Practice points
- **DRAWING IN TONE**
- **DIFFERENT METHODS OF SHADING**
- **WORKING ON COLORED PAPER**

PRELIMINARY SKETCHES

■ You can use any medium that can be quickly smudged and blended to create different tones—soft pencil, charcoal, Conté crayon, or graphite sticks.

Draw the subject from different angles to learn the different forms and observe how they are affected by light.

Keep lines loose and suggestive of shape and stance rather than attempting precision.

Drawing an outline of the shadow that rises and falls over the animal's form helps to emphasize the contours.

Blocking in the background tone helps to throw the form forward, emphasizing the stronger highlights and the solid, cylindrical shape.

A putty eraser can be used to retrieve or strengthen highlight areas.

The darker shadows of the farther-away limbs help give the illusion of depth and explain the spatial relationships.

Areas of tone have to be noted quickly, so use simple hatched pencil lines or broad sweeps of charcoal or Conté sticks on their sides.

Working in monochrome

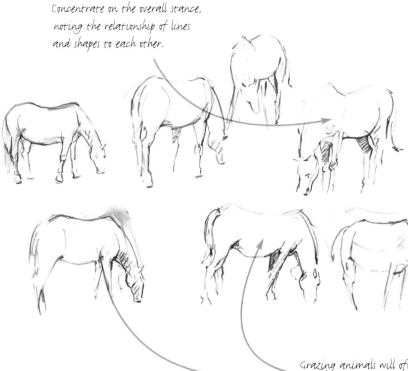

Concentrate on the overall stance, noting the relationship of lines and shapes to each other.

STAGE 1
CAPTURING THE ESSENTIALS

■ Ponies tend to shuffle forward as they graze, causing the shadows to alter with each leg movement. Start with a few rapidly drawn sketches in Conté or charcoal to capture a variety of leg, body, and head angles.

*TIP
Smudging charcoal, Conté, or soft pencil with your finger allows you to lay down shadows very quickly. Identify the main shadows by half-closing your eyes.*

Grazing animals will often repeat similar movements and postures, allowing you to check or add more information.

STAGE 2
BUILDING UP TONE

■ As the ponies keep moving, you can only put in a generalization of the shaded areas, but don't add tone as an afterthought. The stronger and more obvious dark areas should be indicated together with the outlines.

Even a light indication of tone gives a sense of the roundness and solidity of the pony's body.

Tonal areas can help to emphasize the muscle stress as the tension and balance are carried through one or another of the limbs.

Working on colored paper

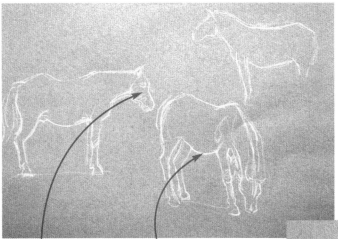

As you become more familiar with the shape and forms, you can begin to add more detail.

Using a neutral-colored paper such as gray or beige, draw the outlines in white Conté or pastel pencil.

Use black Conté or pastel pencil lightly to note the darks.

STAGE 1
DRAWING WITH WHITE

■ Choosing a tinted paper allows you to draw in the highlights instead of reserving them as white paper. This is in many ways easier, as you can work on both the lights and darks at the same time, leaving the paper uncovered or partially covered for the midtones. Once the overall lines are established, you can start to indicate the strongest highlights and the darkest shadows with hatching lines, using both white and black.

Allow the hatched lines to follow the direction of the surface planes to help emphasize the roundness of the form.

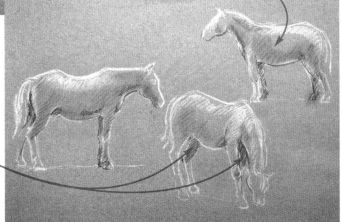

STAGE 2
THE MIDTONES

■ Once you know where the main light and dark areas are to be, you can begin to develop the subtle midtones where necessary. To help distinguish these from the strongest lights and darks, you may find it helpful to use some extra colors such as browns and red-browns for the tonal values rather than for the colors themselves—this is essentially a monochrome study.

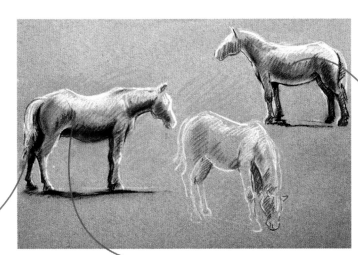

Use midtone colors for the less pronounced shadow areas, smudging them together to achieve soft transitions.

The dark tone used for the far leg throws the tail into relief so that it stands out as a soft but solid form.

The cast shadow, running at right angles to the limbs, anchors the pony and gives it a feeling of weight and solidity.

STAGE 3
EMPHASIZING THE LIGHTS AND DARKS

■ The strongest tones can now be reinforced and even exaggerated if necessary, and the background reevaluated and adjusted to provide either more or less contrast.

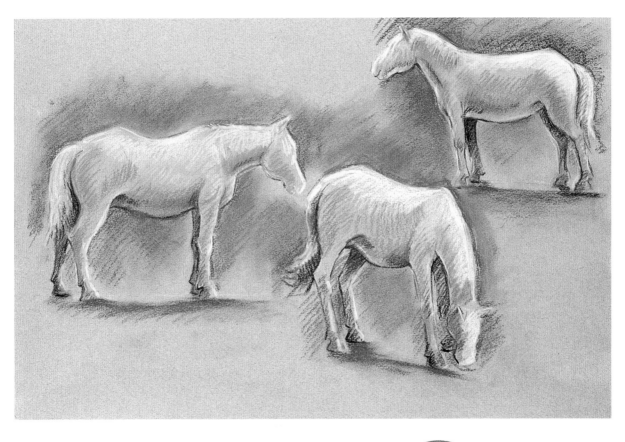

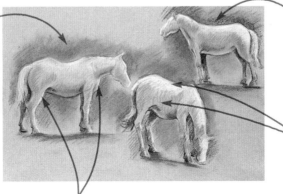

Smudging the background marks makes them less obvious so that the recede into the distance and don't compete with the white highlights on the pony.

Dark brown is taken around the pony's back to emphasize the light-struck areas.

The variety of different marks suggest texture as well as form. Notice that paper does not need to be fully covered in these midtone areas, as it is only slightly lighter than the red-brown Conté crayon.

The original white construction lines are reinforced with a darker crayon to emphasize the shape and define certain contours.

EXERCISE 7

Manx cat
by Kay Gallwey

The coloration is often one of the most exciting aspects of an animal subject, as in the case of this Manx cat, with its lovely pattern of ginger on white, but before you can engage with color and pattern you must be able to identify the underlying forms. A good exercise is to make sketches in monochrome—pencil, brush, and ink or even a felt-tip pen—to discover ways of describing form either through line or through a combination of line and tone. For this demonstration, the artist makes a series of pencil sketches which she then uses as a basis for a composition done in just four colors of Conté crayon—black, white, sepia, and dark brown. Limiting the colors prevents you from becoming bogged down in detail, which can destroy the sense of form.

Practice points

- **USING LINE TO DESCRIBE FORM**
- **DRAWING WITH FOUR COLORS**
- **DESCRIBING TEXTURE**

EXPLORATORY SKETCHES

■ Start by making as many sketches as possible, working mainly in line, but looking for the way the lines show the forms. It helps to sit by your cat as you draw, as it will often return to a similar position, allowing you to finish a sketch you began earlier.

Accurately drawn outlines can give a very good impression of form without the need for shading.

Dark shadows behind and below the leg clarify the shape and form.

Apply thicker lines and loose areas of hatching to indicate the forms turning away from the light.

The fur itself makes its own forms. Suggest the bottom of the ruff of fur around the neck with quick squiggling lines that also give the impression of the texture.

The eyes, nose, and mouth establish the position of the head. Put in detail only where it plays an explanatory role.

A little shading can be needed to help explain the positions of the limbs.

Notice how the shape of the outline changes according to whether the leg is outstretched or relaxed and slightly bent

DRAWING DETAILS

■ Draw bits of the cat, such as the paws and pads, the eyes, and the ears with their characteristic tufts of fur. This will help you to build up an overall picture and to understand the shapes and proportions.

Draw the eyes in relation to the nose. This cat has a relatively short nose and large eyes.

Notice how the anklebone shows here because the fur is short.

PLANNING THE FINAL DRAWING

■ Make the preparatory sketches as quickly as you can, but don't rush into the picture itself without planning, as you will be taking a lot more time over this. Make several small sketches to try out different poses and compositions.

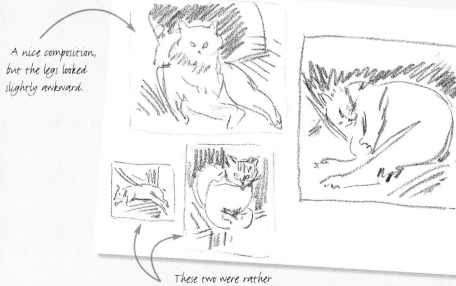

A nice composition, but the legs looked slightly awkward.

The figure of the cat fills the square format nicely, with the tilted head and diagonal of the legs making a strong composition.

These two were rather boring, and the pose on the right slightly hackneyed.

STAGE 1
THE UNDERDRAWING

■ You will be working with just four colors on tinted paper. The artist has chosen a beige paper, as this provides a midtone to bring out both the highlights and the darks. Sketch the cat lightly, leaving space around it in case you want to include some background later.

TIP
It can be helpful to work on a piece of paper that is larger than you think you will need so that you can expand the composition if you wish. The paper can be trimmed to the required size before mounting and framing.

Suggest the fur with a variety of strokes, but leave some of the lines "clean" to give form and structure to the animal.

STAGE 2
BLOCKING IN THE WHITES

■ Once you are satisfied with the drawing, start to put in the highlights, using the Conté crayon on its side to produce broad strokes.

Vary the direction of the strokes to give the impression of the soft, fluffy texture of the fur.

Take great care to get the tilt of the head right, drawing lightly so that you can make corrections if need be.

STAGE 3
THE MIDTONE

■ Now add some darker tone, using the sepia Conté crayon in the same way, and concentrating on the forms rather than the precise details of the markings.

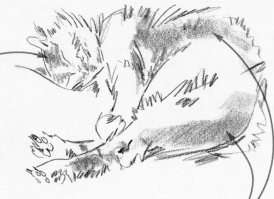

You can give a stronger indication of the pattern in this area, and leave some of the body markings to the imagination.

Sweep the crayon around the forms of the leg and back, ignoring any ginger patches that cut across a form.

STAGE 4
FINISHING THE DRAWING

■ For the final stages, use all four colors at the same time, taking care to keep the whites pure and unsullied. Use the tips of the Conté crayons mainly, as the broad areas of tone are already in place, and build up the texture of the fur with long and short marks following different directions. When you think you have finished, spray the drawing with fixative and pin it up on the wall to assess it; you can add more detail if you think it necessary. The artist decided to restrict the background to no more than a line and some shading to suggest the cushion beneath his head.

Make dark strokes of black to bring out the white on the side of the face.

Use all four colors to bring depth into the picture, using light but strong strokes to get the feel of the long, fluffy fur.

Draw in the eyes and any other detail such as the ears and whiskers with the black Conté.

Use the side of the Conté very lightly and rub over it with a finger to suggest the softness of the paw pads.

Penguins by David Boys

While drawing various different animals you may notice that many have evolved their coloration to help disguise and protect them against predators. Penguins are darker along the topside and much lighter underneath. The darker side absorbs the light, so that less is reflected back, thus reducing the highlights, while the lighter underbelly facing the shadows reflects as much light as possible. This camouflage makes the whole form of the creature appear flattened. So to give the impression of solid mass it is necessary for the artist to ignore the coloration to some extent, concentrating first on tone and the way the fall of light models the forms.

Practice points

- **MAKING WARM-UP SKETCHES**
- **LOOKING FOR INTERESTING SHAPES**
- **IDENTIFYING TONES**

PREPARATORY SKETCHES

■ Penguins are delightful subjects: Along with being endearing in themselves, with their awkward, upright, waddling postures, they also provide interesting shapes, patterns, and forms. Before starting on a finished drawing or painting, the artist likes to make a series of "warm-up" sketches to get the feel of the shapes and postures. This also helps him to make decisions about how he will develop the drawing and place the shapes.

STAGE 1

PLANNING THE DRAWING

■ He decides to concentrate initially on three groups of birds, contrasting those lying down in the front of the picture with the standing birds behind, but he leaves some free space to allow him to add more birds if interesting postures present themselves. He begins the drawing in pencil, and will add watercolor washes once he firmly establishes the shapes and indicates the tones.

Don't be too rigid with the pencil outlines or the sketch will appear tight and constrained.

You can add extra interest by juxtaposing shapes, and when the color is added, this will become a lively area of tonal counterchange.

The tones will mainly be built up with watercolor washes, but indicate the darker tones at the outset with a few lines of diagonal hatching.

STAGE 2

LAYING WASHES OVER PENCIL

■ When working in watercolor, it is best to make a fairly complete—but not overworked—pencil drawing, and wait for a convenient moment to lay on washes. In this case, the torpedo-shaped juvenile birds are lying down very much at ease, providing the artist with the chance to explore the fall of light using colored washes before the penguins change position.

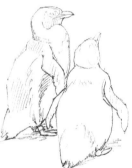

Loosely apply a mix of French Ultramarine and Light Red to indicate the darkest areas of the black coloration.

For the browner face patterns of the younger birds, use the same colors but with a higher proportion of the red to give a warmer hue.

It is important to jot down the cast shadows quickly because they will change, and if you try to add them later they may be inconsistent.

STAGE 3
DARKENING THE TONES

■ Leave the first washes to dry, and while waiting, start work on the two left-hand birds, using the same colors to mix a neutral wash for the darker tones. Paint the darker tones on the white breast and belly of the standing adult bird with a light wash of Cobalt Blue and a touch of Yellow Ochre. Leave this to dry and then return to the foreground birds, laying a pale wash of the same mixture but with more blue over the darkest areas.

Look for a suggestion of the ground color in the shadows, which you can repeat in adjacent pale areas.

Be careful not to paint over any white details, such as the markings over the eye, the beak, and along the edges of the flippers (wings).

Keep the layers of watercolor transparent so that the light areas shine through as highlights while the previous dark tones are reinforced with the Cobalt Blue and Yellow Ochre mixture. If necessary these can be accentuated with the addition of Payne's Gray.

STAGE 4
HIGHLIGHTING THE WHITES

■ You can now begin to build up the dark areas of the standing birds in the same way. To highlight the whites on the head and breast of the left-hand bird you will need to tone the surrounding white paper, so lay a loose background wash of Cobalt Blue with a little Yellow Ochre. Add more Yellow Ochre to the mixture for the ground beneath the birds, accentuating the darker areas of shadows with additional Cobalt Blue.

When laying background washes, don't mix the colors too thoroughly, as partial mixing gives more interesting passages of color.

Look for shadows on the body, such as that below the wing, as these help to explain the forms and their spatial relationship.

As soon as you put in the shadows, the birds begin to look three-dimensional.

Adult birds have a small area of pink blush, which is more noticeable when they are breeding.

The undersides of the flippers are white, but they appear dark in tone because they are in shadow. Lay a Cobalt Blue wash and add the darker markings when the wash is dry.

Diluted cool Cobalt Blue is used for the shadows on the breast and belly, with a hint of Yellow Ochre for the reflected color in the areas nearest to the ground.

STAGE 5
ADDING TO THE COMPOSITION

■ Similar washes are applied to the right-hand group of birds and, while working, the artist notices another interesting posture. He quickly captures the shape of the preening bird, which conveniently fills the empty corner space.

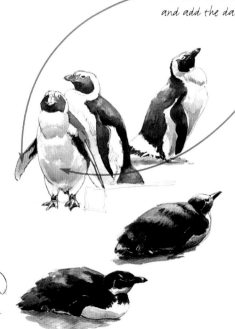

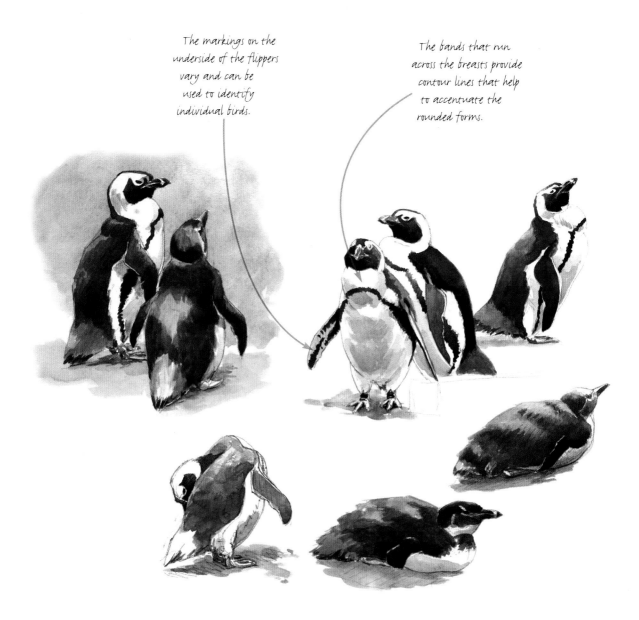

The markings on the underside of the flippers vary and can be used to identify individual birds.

The bands that run across the breasts provide contour lines that help to accentuate the rounded forms.

STAGE 6
ADDING DETAIL

■ When adding extra elements to the composition it is vital to maintain consistency, so the same color mixtures are used to fix the tones of the preening bird before it changes position and the information is lost. At the same time, the black coloration of the other standing birds is built up, bringing them all to a similar stage of completion.

TIP
A great many different but related hues can be mixed with any two of the primary colors, blue, red, and yellow.

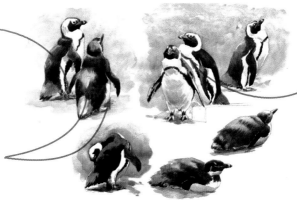

Details of the feet show blotched pink areas as well as dark patches. Like the wing markings, these vary with individual birds.

Overlapping these two birds has allowed the artist to create a lively tonal pattern.

Notice that the highlights on the black areas are not much darker than the shadows on the whites, yet they still read as black.

STAGE 7
FINAL TOUCHES

■ The preening bird requires careful handling of tone to explain the posture and forms, so develop the dark areas and strengthen the shadows on the white areas. Finally, place a background wash behind all the individual studies, helping to unify them as a group and to throw the whites into relief.

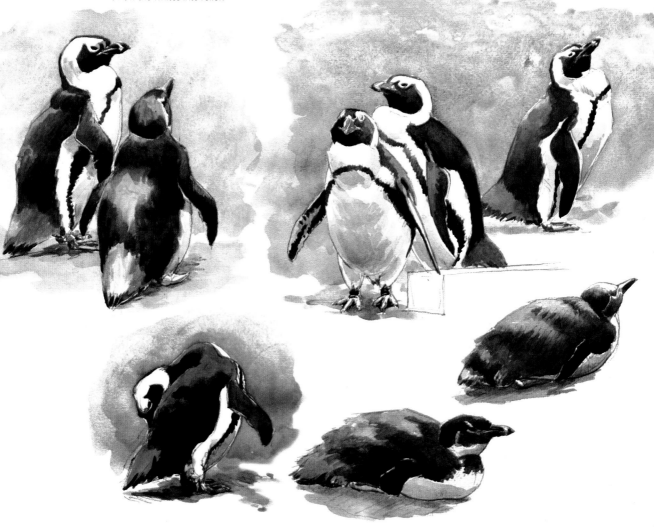

THE FUNDAMENTALS

Drawing with color

Patterns and color *The animal world is replete with fascinating combinations of patterns, textures, and colors, be they on animal hides or skins, or part of the flamboyant plumage of many birds.*

Dry and wet mediums *You can choose from a wide range of different color mediums, including colored pencils, watercolors, and pastel pencils.*

When you first begin to draw animals your main concerns will be with the inherent difficulties of the subject—how to render movement and understand the structures—and you may not give much thought to developing your drawings in color. But much of the fascination of the animal world lies in the endlessly varied coloration and rich patterns of markings, so as you explore new subjects and gain experience you may find that using color enables you to give a more complete account of the animal.

Choosing the medium

If you are sketching on the spot, you will need a light, portable medium. Small boxes of watercolors are the choice of many professional animal artists, but colored pencils are an alternative well worth trying, especially the water-soluble ones, which allow you to spread the color with a wet brush.

For studio work, your choice is much wider, indeed you can use more or less any medium you choose, from pastels to any kind of paints. But always consider what it is you want to convey: A study of a sleeping cat or dog could look fine in oils or acrylics, but there is always a tendency to overwork these opaque paints. So if you want to suggest movement and give a spontaneous, sketchlike quality to your work, loosely worked pastels or watercolor washes over pen or pencil line could be better choices.

Choosing colors

If you are buying a new medium you will have to decide on the necessary colors. You seldom require as many as you think, because a large range can be mixed from a few basics (in pastel or colored pencil, you mix colors by laying one over another). For most animal subjects you will need a range of the earth colors—browns, red-browns, and ochers, and for any subject the three primaries—red,

The power of color *The addition of subtle watercolor browns, grays, and yellows brings life and three-dimensional form to this drawing of an owl.*

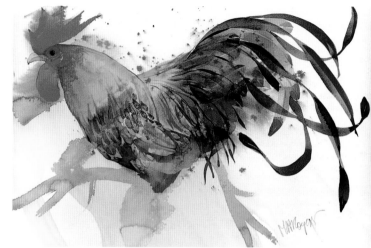

blue, and yellow—are essential, as these cannot be mixed from any other colors. Greens can be easily mixed from blue and yellow, but having one or two tube greens in your kit does save time when you want to make a quick note of grass or foliage.

Palette of colors
This example of an artist's palette includes a range of reds, blues, greens, and earth colors.

Color properties

In order to paint successfully it is important to understand two of the simpler basics of color theory, the first being the concept of "color temperature."

Colors such as red, yellow, and orange appear warmer than the blues and greens, and come forward in space, so you can give the impression of depth in your work by using cooler colors in the background. Even the secondary colors like green, and the so-called neutrals like brown have warm and cool versions. A yellowish green is warmer than a bluish one, and a red-brown is warmer than a purplish brown.

Complementary colors are the colors that fall opposite one another on the color wheel—red and green, yellow and violet, and blue and orange. These create very strong contrasts, which can be used to enliven a painting.

Scarlet Lake	Alizarin Crimson	Payne's Gray
French Ultramarine	Cobalt Blue	Cerulean Blue
Naples Yellow	Raw Sienna	Burnt Sienna
Light Red	Indian Red	Burnt Umber
Lemon Yellow Hue	Aureolian	Sap Green
Oxide of Chromium	Prussian Green	Cobalt Green

"Dash"
Watercolor *The combination of bold colors and loose, painterly watercolor style gives this sketch its "dash" and energy while conveying much of the subject's dominating character.*

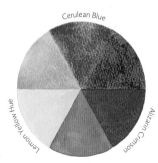

Warm and cool grays *You can mix a warm blue and a warm red to create a warm gray (near right) and mix cool versions of the same two colors to produce a cool gray (far right).*

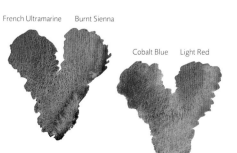

French Ultramarine Burnt Sienna

Cobalt Blue Light Red

Color wheels *Warm versions of the primary colors are shown right (top), and cool versions, right. You can create secondary colors by mixing any two primary colors together, producing orange, green, and violet. Mixing all three primary colors produces a range of grays and browns. Complementary colors fall directly opposite one another on the color wheel.*

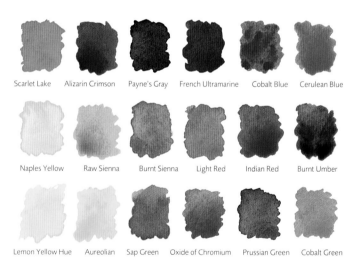

French Ultramarine

Aureolian

Scarlet Lake

Cerulean Blue

Lemon Yellow Hue

Alizarin Crimson

EXERCISE *9*

Cotton-top tamarins
by David Boys

These small and charming primates are inhabitants of the Amazonian rainforests of South America. Their striking white "hairstyles" and inquisitive expressions make them endearing characters to draw and paint, and their long, lustrous red-brown tails invite a color treatment. The artist is working in watercolor. He emphasizes the forms of the monkeys and creates a feeling of space by juxtaposing warm and cool colors (see page 51). Warm colors tend to advance to the front of the picture, while cool ones recede, so you can give a three-dimensional quality to your work by warming the mixtures for any part of the form that needs to come forward in space.

Practice points

- **USING WARM AND COOL COLORS**
- **DESCRIBING FORM AND DISTANCE**
- **RESERVING HIGHLIGHTS**

Details can be put in only after the main shape is established, drawing on close observations and knowledge gained from previous drawings.

Take care to leave white paper between the brushstrokes in any highlight areas. It is better to reserve too much highlight than too little; you can add color later, but it is difficult to reclaim lost highlights.

STAGE 1
ESTABLISHING THE STRUCTURE

■ Watercolor paintings require advance planning, as mistakes cannot easily be rectified without overworking the paint and thus losing the fresh, spontaneous feeling. Start with a careful pencil drawing to capture the postures in relation to the branch, and when you are satisfied with this, lay washes of Raw Sienna over the areas that need a warm undertone to help them come forward.

Use the color more strongly toward the front of the picture plane.

The gray shadow areas help to accentuate the animals' forms, which must be indicated before any finer details are added.

If you want to retain crisp edges on juxtaposed or overlapping shapes, make sure the first wash is dry before putting on the next. An alternative is to leave tiny lines of white paper between the two shapes.

STAGE 2
THE UNDERLYING GRAYS

■ It is seldom wise to use watered-down black for the grays, as this has a deadening effect. Instead, mix a range of "colored grays" from blue and red—here the artist uses mixtures of Ultramarine Blue and Light Red to indicate shadows on the white fur of the heads, forearms, and chests. This gray is warmed with more red to build up the darker color around the faces, which helps to draw the eye in to the main focal points.

Use some of the blue-gray mixture to paint some light shadows on the front of the branch. Repeating colors from one part of the picture helps it to hang together as a whole.

Suggest the general mass of the fur with brushstrokes of cool gray, varying the direction of the strokes to give a hint of the texture.

Leave small lines of white highlight following the direction of the hairs.

STAGE 3
BUILDING UP THE FORMS

■ Now you can begin to work on the darker colors. For the tail and the patches of hot color on the bodies, use combinations of Raw Sienna and Light Red, warm colors that will enliven the grays and browns. To build up the solid form and weight of the supporting branch, use cooler colors for the shadows— a mixture of Ultramarine Blue and Burnt Umber. The branch is an important element in the composition, as it contrasts with the more delicate and fragile forms of the monkeys.

Paint wet-in-wet in this area, dropping darker colors into the first wash while still damp so that they run into one another.

To give an overall consistency to the painting, paint the dark tip and the shadows on the tail with the mixture of colors you used for the branch.

Make some of the edges and tones crisp and well defined, allowing others to dissolve into the background to help the feeling of recession.

Allow some pale areas to show through to achieve a broken-color effect. This is livelier and more interesting than flat color.

Mix the colors for the background on the paper rather than in the palette, with loose washes of Cobalt Blue laid over Lemon Yellow (both cool colors).

STAGE 4
THE BACKGROUND

■ The white fur on the heads and chests are one of the monkeys' most attractive features, and need to be emphasized by painting a darker-toned background. This must be a cool color so that it recedes, and the artist decides on bluish-greens with touches of yellow, giving a suggestion of a foliage context.

The eyes, just like ours, are set in deep sockets, which can be indicated by a dark shadow under the brow.

STAGE 5
FACIAL FEATURES

■ With the background in place, the white hair seems to jump off the page, drawing the eye to the hitherto undefined faces of the monkeys. These are the main centers of interest, and require careful treatment, but try not to overwork the paint—make each brushstroke as descriptive as possible.

To help the white areas of the faces to stand out, use the strong dark-gray mix to strengthen the dark patches around the faces and under the chins.

The pupils of the eyes are almost black, so you can use a stronger version of the blue-gray mix, adding a tiny highlight with opaque white to make the faces come alive.

You need no more than one brushstroke to paint the mouths and nostrils, so don't be tempted to worry away at them with a tiny brush.

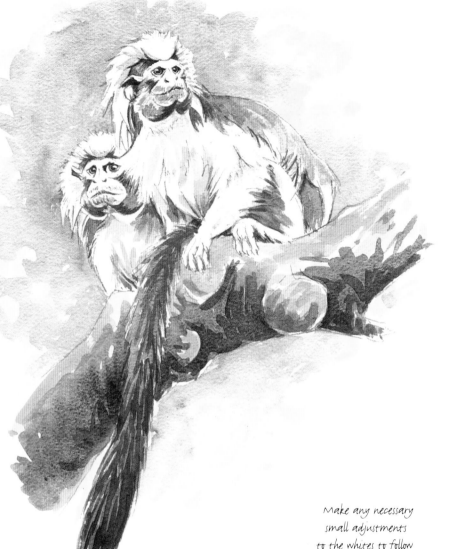

To help you learn to draw eyes, practice drawing ellipses—circles seen from different angles. But remember that the sphere of the eye is set into a socket, so you may only see a small section of the whole surface.

Make any necessary small adjustments to the whites to follow other areas of shadow.

Pick out a few of the more obvious details of the fur with a darker tone to provide more contrast in this area.

STAGE 6
FINAL ADJUSTMENTS

■ All that is now needed to complete the sketch are a few adjustments to balance the overall color, most importantly strengthening the warm mustard color on the back of the foreground monkey and adding more tone and definition to the tail.

Build up the tones and colors of the tail with further applications of Burnt Sienna and Light Red, and accentuate the dark tip with Payne's Gray and Ultramarine Blue. Use this mixture on the branch to create a link between the two forms.

When the darkest tones are strengthened, the background color recedes even farther into the distance.

EXERCISE IO

Black-cheeked lovebirds
by David Boys

Everything we see has its own color, which is called its "local" color, and if we were to describe an object, animal or person, we would use this as a descriptive term—a yellow vase, a brown horse, a rosy complexion, and so on. But the effects of light alter colors dramatically, so when painting you must be aware of both the local color and of what the light does to it. A color that appears bright and vibrant where the light strikes a surface will become subtler, cooler, and darker in tone in the shadowed areas, sometimes appearing as a different hue altogether. It can be instructive to look at your chosen subject under different lighting conditions and try to analyze highlight and shadow colors.

Practice points

- **CAPTURING LIGHT EFFECTS**
- **USING STRONG COLOR**
- **DESCRIBING FORM**

STAGE 1
LINE AND COLOR

■ The artist begins with a pencil drawing, concentrating initially on the interesting shapes and patterns made by the birds and the branches. He then identifies the most vivid and luminous colors—those of the chests—and paints them quickly with strong greens and yellow-greens to capture their purity on the white paper. Using strong, pure colors from the outset avoids having to lay on further washes, which can sully the colors.

Pencil lines following around the branches (bracelet shading) describe their form and act as a guide for laying on the color.

The vivid bright greens, heightened by the strong light, are predominantly yellow-based. A wash of Winsor Lemon is applied first, with Cobalt Green added for the darker, denser colors.

A few quickly drawn hatched lines indicate shadow patterns and remind you of the form.

STAGE 2
LIGHT AND SHADE

■ The two birds on the left are the most affected by light and shade. One is resting in the shadows, with only its tail and wing top caught by the sun, and the other has a cast shadow from the branch across its body. Work on this area first, laying a simple wash of Cobalt Blue over the whole of the shadow area, leaving a few patches of white paper where the light falls on the branch. When this wash is dry, start to paint the wings of both groups of birds.

Use a fairly strong blue wash, but don't make it so dark that it obscures the drawing lines.

The branch and the bird are seen as an integral part of one another, so paint both at the same time.

The wings are a strong Turquoise Blue, and a darker tone than the chest plumage. Use a mixture of Cobalt Green and Cobalt Blue, applying the paint with the tip of the brush, and leaving small white highlights.

STAGE 3
COLOR AS TONE

■ The next stage is to paint the heads with a base color of Raw Sienna with a touch of Cobalt Green and then look for other tones that will help to describe the forms, such as the dark shadows under the curves of the heads and under the tail vent. Because the light is bright, the tonal contrasts are quite marked, so don't be afraid to use strong tones.

Darken the color with a strong mixture of Raw Sienna and Cobalt Green.

Although the face masks are darker than the rest of the head, leave them white at this stage so that the subsequent colors remain pure and unsullied.

An overall darker tone is created where the base color for the heads is laid over the original blue wash.

This side of the face mask is in shadow, so you can use the Raw Sienna head color as an undertone to help darken the final color.

STAGE 4
BUILDING UP THE COLOR

■ Now that the forms have been indicated and the direction of the light established, you can add the other colors on the birds, including the dark face masks, but take care with the reds, as they could easily dominate the other colors. Mix together some Naples Yellow and a hint of Scarlet Lake and lay a wash of the mixture. Then paint small brushstrokes of the same mixture, leaving lighter patches showing through.

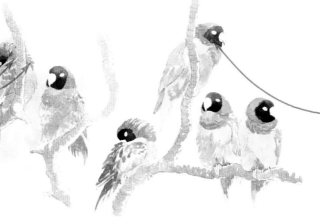

The bright feathers showing at each side of the branch clarify the spatial relationships.

Paint the foreheads with Burnt Sienna, darkening the color with additions of Payne's Gray where the forms turn around and under. Leave the beaks as white paper.

STAGE 5
ADDING COLOR AND DETAIL

■ The brilliance of the white paper competes with the colors of the birds, so a wash of background color is needed to make the colors glow. The artist decides to bring in a cool purple mixture of Alizarin Crimson and Cobalt Blue to contrast with the glowing yellow-green belly feathers. For details, use a strong Scarlet Lake to paint the brilliant, eye-catching red bills, which form a series of "hot spots," leading the eye from one part of the picture to another. Detail can then be elaborated, but don't give equal emphasis to every part of the birds. Some feather patterns on the wings and breast can be merely suggested, while the wing primary feathers, stiffer and larger than the others, require more solid definition.

Strengthen the first wash with a warmer mixture of Ultramarine Blue and Burnt Sienna. This has a similar color value to that of the birds, and helps them to blend into the background.

Paint another cast shadow with Cobalt Blue to emphasize the bright sunlight and also create a feeling of distance between the bird and its vertical perch.

Apply the wash loosely, as before, letting the colors blend together on the paper rather than premixing them.

These feathers are edged with brown, so appear darker. Bring in some of the brown mixture used for the heads to create a tonal balance.

Too much definition here would lose the soft, downy quality of the feathers.

STAGE 6
FINAL ADJUSTMENTS

■ A few final adjustments can now be made to the colors and tones, mainly those of the branches, which require more contrast to build up the forms and enhance the impression of bright light.

By tilting your board, you can encourage the paint to flow downward to form a puddle at the bottom, thus achieving different tones in just one brushstroke.

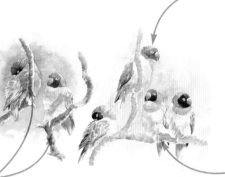

Finish the dark centers of the eyes as the final "punctuation marks."

The feet, which have been reserved as white paper from the start, can be given slightly more definition by carefully extending a wash around them.

These branches are darker than those on the right, so paint over them with Burnt Sienna, leaving highlights at the edges. Then add Ultramarine Blue to the mixture and drop in small touches of shadow.

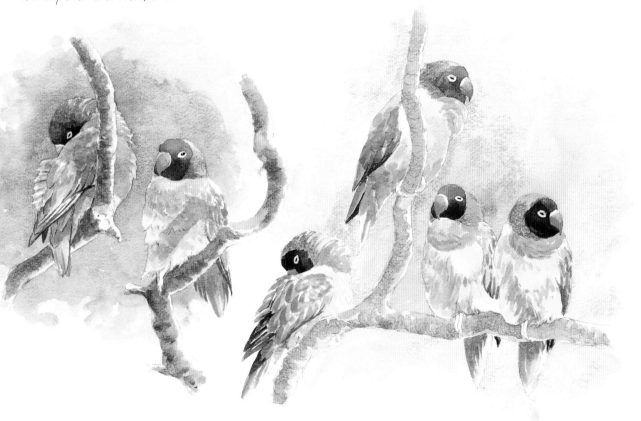

THE FUNDAMENTALS
Animals in context

Natural habitats
When sketching animals in the wild or outdoors, learn to observe them in the full context of their natural environment.

When you first begin to sketch birds and animals, the creatures themselves will obviously be the focus of your attention, especially when they are in constant movement. But as your drawings progress, with shapes and postures beginning to emerge on the pages of your sketchbook, you may see that you could make them more meaningful by giving an idea of the animals' surroundings.

The environment

Animals and birds are part of the natural world, constantly interacting with it. A drawing of sheep in a field, or horses grazing, will tell a more complete story if you sketch in the ground, and perhaps give an idea of the kind of landscape the animals inhabit. A study of penguins below the water will be more comprehensible if you indicate the water, and even flying birds, seemingly attached to nothing, are still part of the wind currents and air space they displace.

Sometimes you will have to include the surroundings without making a conscious choice about it, as they may impact on the form of the animal. For example, the legs and part of the body of a mountain goat might be partially obscured by one of the rocks that form its perch, or the shapes of birds may be interwoven with foliage patterns.

Interiors *The cat and the wrapping paper on which it lies appear to merge into one in this sketch, conveying the creature's contentedness in its home environment. The sketch also shows the love the artist feels for her pet.*

Deciding on the detail

The degree of detail you include depends very much on the intention of your drawing. If you are taking a sketchy, impressionistic approach, a few lines indicating the ground on which the animal stands, and perhaps a light

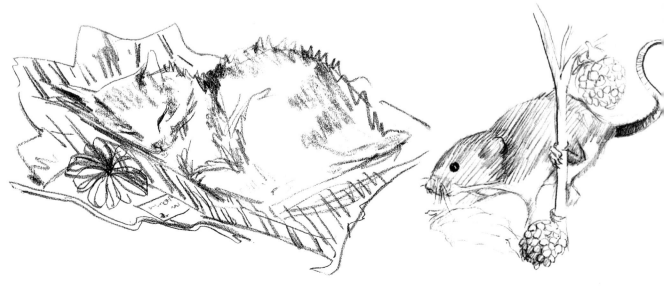

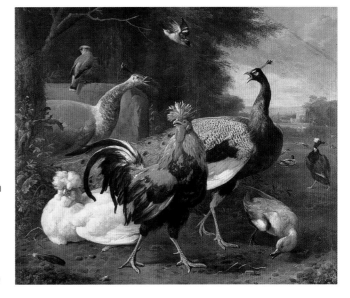

suggestion of trees or rocks, could suffice. But for a more detailed study, perhaps of a cow in a barn or some similar subject, the surroundings might form an important part of the composition and bring a narrative element into the work. In the same way, you could hint at a story in a study of a domestic pet by drawing it on a favorite chair or cushion. But avoid bringing in detail that has no relevance to your drawing, as this will only weaken it and shift the focus of attention from the main subject.

A cockerel with other birds *The 17th-century Dutch painter Melchior de Hondecoeter specialized in painting scenes of farmyards showing a great number of different birds.*

Taking a broader view

Sometimes, however, you may want to focus on the setting itself, whether a landscape or an interior, with the animals playing a minor role. Over the centuries, many artists have painted landscapes with animals, one of the most celebrated being the seventeenth-century Dutch painter Aelbert Cuyp, famous for his lovely paintings of landscapes with cows, in which the large, slow forms of the animals enhance the feeling of quiet serenity.

In such cases, it is important to consider the relationship of landscape and animals rather than grafting a sketchbook study onto an unconnected setting. Early bird illustrators like Thomas Bewick featured their subjects almost like film stars, posing in the foreground with a suitable backdrop superimposed behind. Background and subjects were rarely considered as one. Always try to view the picture as a whole, as all the elements of the landscape, including the animals, are interdependent, with the tones and colors—of sky, hills or fields, and trees—affected by the same lighting conditions.

African summer *With just a few trees and a vibrant patch of ground the artist added warmth and narrative to this gentle watercolor sketch of cows at rest on a summer's day.*

Mouse at work *By sketching this field mouse in action on a raspberry stalk, the artist describes something of the animal's day-to-day activities and the nature of its movements. She used pencil to lightly draw the mouse's outline, with loose shading added in for texture and highlights.*

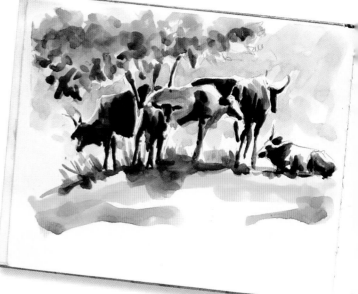

EXERCISE II

Vervet monkeys
by Julia Cassels

Some animals are so dependent on and interactive with their environment that it would be unrealistic to depict them other than as part of it. And in the case of birds or tree-dwelling mammals, the setting of branches and foliage gives you additional compositional elements and explains animal posture and balance.

Here the sunlight dancing through the foliage fuses the monkeys and the trees together into a mass of dappled shapes that invites a loose watercolor treatment, but the drawing also needs structure, and this is provided by a strong pencil drawing to which the color is added in the later stages.

Practice points
- BUILDING UP PATTERN AND COLOR
- COMBINING MONOCHROME AND COLOR MEDIUMS
- WORKING WET-IN-WET

PRELIMINARY SKETCHES

■ Start with some preliminary sketches to plot the shapes, proportions, and tonal pattern. If you are out in the field with a sketchbook you need to be able to capture the essence of your subject quickly, and your sketches will be your guide for a later painting, so use whichever medium suits you and best helps you to commit the subject to memory.

Quick linear work plots the shape and posture of the monkey.

Roughly sketch in the shapes and indicate the tone with quick crosshatched strokes.

Use the tip of the charcoal stick to indicate the shape, then give it substance by placing the dark ear and face.

The lights and darks can be emphasized by using a very soft pencil and varying the pressure.

To make quick color notes, draw with a permanent ink pen and then lay loose watercolor washes on top.

By smudging the charcoal gently with a finger you can suggest both the texture and the form.

Forms can be built up quickly by washing over water-soluble pen lines with water.

STAGE 1

STARTING THE DRAWING

■ In order to be able to work freely in watercolor later on it is essential to have a good and accurate structure in place first, so begin with a pencil drawing and then reinforce it with pen lines. But try to keep it light and sketchy—it is all too easy to overwork the initial drawing.

Establish the direction of the light with some crosshatching in the shadowed areas.

Scribble a few of the leaves in very loosely to give a guide for placing the washes.

Going over the pencil lines with pen gives form and definition and suggests the weight of the branch.

A series of sketchy crosshatched lines begins to build up the three-dimensional forms.

STAGE 2

REFINING THE DRAWING

■ Now you can begin to clarify the initial tangle of lines and add form to the branches and monkeys. Work on all the elements of the composition at the same time, as they are interwoven and are all of equal importance.

Light crosshatching different from that used on the tree differentiates the two elements and plots the tone of the monkey's body.

A combination of squiggled lines and crosshatching suggests the texture and solid weight of the branch.

Darken both the faces so that they stand out from the foliage and branches.

STAGE 3
LAYING THE FIRST WASHES

■ Before laying on the color, the artist adds a little charcoal to emphasize the darker areas. She then paints a light watercolor wash over the branches, reserving the highlights as white paper to exaggerate the brightness of the light. To give the sketch a fresh, spontaneous look, the paper is damped to encourage the colors to bleed into one another.

The charcoal emphasizes the contrast between the dark face and the pale fur that frames it.

The addition of charcoal strengthens the shadow. The watercolor washes "fix" the charcoal so that it does not smudge.

A range of browns and gray-browns (Burnt Sienna, Brown Madder, Raw Umber, Cobalt Blue and Manganese Blue) are allowed to bleed together.

To avoid color spreading into the highlight areas, damp the paper selectively, leaving it dry where you want to reserve white paper.

When the washes have dried, add touches of charcoal to give a little definition to the nearer ones.

STAGE 4
WORKING THE FOLIAGE

■ Before working any further on the monkeys, begin to paint the foliage with loose, splotchy brushstrokes of different tones of green. Again, wet the paper where you want the colors to blend.

Use mixtures of Hooker's Green and Lemon Yellow, or similar colors, dropping darker tones into the washes while still wet.

STAGE 5
CONTRAST AND BALANCE

■ Painting the branches and foliage first makes it easier to assess the colors needed for the monkeys. Their golden hues can be exaggerated slightly to contrast with the greens of the foliage and the slightly duller browns of the tree, but don't bring in too much contrast—as you don't want the monkeys to seem to "jump" out of the tree. They are an integral part of the "treescape" and must not be given too much importance.

A small touch of Antwerp Blue added to the pale fur creates the shadow and brings in a little tonal contrast.

Allow the leaves and fur to blend together so that the monkey appears to be part of the tree.

Use a large brush and Burnt Sienna to wash over the pencil lines. You need not be too precise with the washes, as the drawing provides the structure.

TIP
When working wet-into-wet, remember that dry paper acts like a wall, containing the wash, so leave it dry wherever you want crisp edges.

TIP
By keeping the brush constantly moving and "dancing," you will mimic the effects of sunlight and prevent the watercolor from becoming overworked.

Use cool blues such as Antwerp Blue and Cobalt Blue for the shadows to contrast with the warmer hues of the fur.

Emphasizing the tail of the top monkey creates a relationship between the two monkeys and strengthens the overall pattern.

A touch of the reddish color of the monkey's coat is brought in here as a counterbalance.

STAGE 6
INCREASING THE CONTRASTS

■ Complete the second monkey, using contrasts of warm and cool colors (see page 51) to build up the forms and give an extra sparkle to the painting. It is always best to use pure colors wherever possible, as dull brown or gray shadows can have a deadening effect.

STAGE 7
FINISHING TOUCHES
■ The final stage is to add the purplish shadows that anchor the monkeys to the branches and enhance the effect of the creatures being at one with their environment.

The body of the monkey casts a warm shadow over the rounded branches.

Always try to leave small areas of white paper, as they help to suggest the dappled light and create a lively, vibrant effect.

The static forms of the branches contrast with the agile, twisting bodies, which seem to contort effortlessly to accommodate themselves to its angles.

EXERCISE 12
Seabird colony
by Darren Woodhead

This boisterous seabird colony in summer, with the sunlight forming dappled patterns on the birds and their rocky perches, makes a wonderful subject in which to explore the interaction of shapes and colors. For a painting like this, detail is not important—what matters is postures, angles, and shapes, so spend time observing and thinking about how you can best distill the essence of the scene. You may at first be daunted by the sheer numbers of birds, but poses will be repeated regularly, allowing you to single out the more interesting ones and plan the composition accordingly. When working directly in watercolor, as in this demonstration, it is essential to have a clear idea of the overall design from the outset, especially when large areas of paper are to be left white.

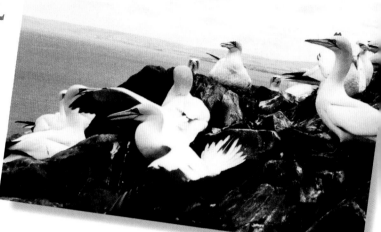

Practice points
- **IDENTIFYING THE MAIN SHAPES**
- **WORKING DIRECTLY WITH THE BRUSH**
- **USING A LIMITED PALETTE**

PREPARATORY SKETCHES

■ Don't waste expensive paper on preliminary sketches—they should be seen simply as a means of getting to know your subject and exploring possibilities. Start with pencil sketches and then make quick color notes.

You can support pencil line by a quick wash of watercolor to emphasize shadow and shape.

Using a soft pencil, and working on drawing paper, make rapid, firm lines, suggesting form with lines of hatching.

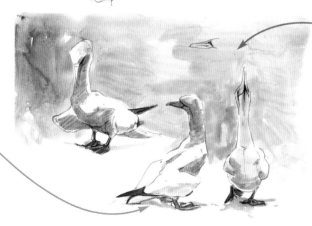

To support the forms and make a note of the lighting conditions, indicate any cast shadows as well as those on the birds themselves.

A wash of background color will immediately relate the subject to its environment and bring out the white of the plumage.

STAGE 1
BRUSH DRAWING

■ Painting directly with the brush is different to "filling in" a pencil outline, and requires careful analysis of tones and the shapes they make. Begin by deciding where the whites are to be, and then paint the shadows of the birds with a large brush, using a neutral gray mixed from Cobalt Blue and Light Red. Ignore the outlines for the time being, as these will be picked up later.

TIP

Let the water do the work for you, keeping the brush well loaded so that it glides over the paper. You may make mistakes, but these can often be exciting in themselves.

The group of smaller birds in the background gives an interesting variety of large and small shapes and indicates depth.

The shadow on the breast of the bird behind will help to pick out the white neck of the one in front.

Keep the shapes as simple as possible, but don't make them too regular in outline—look for wavy edges caused by the way the light strikes the plumage.

STAGE 2
ADDING COLOR

■ Introduce colors gradually, starting by painting the distinctive yellow of the heads with Aureolin Yellow, and letting this overlap the previous wash to suggest the local color of the shadow. Don't bring in too many different colors: you can use a stronger mix of the original blue-red neutral color for the details, and variations of the same but with more red for the wingtips catching the sun and the shadows beneath the birds. The artist uses only five colors throughout the painting —Cobalt Blue, Ultramarine Blue, Aureolin Yellow, Light Red, and Yellow Ochre.

As soon as some simple detail is added the gulls begin to take shape as birds rather than abstract shapes.

TIP

It is vital to keep colors fresh and clean, so change your water regularly. When working on location, take a large plastic water bottle with you.

A wide range of hues can be achieved by mixing the basic red and blue in different proportions. Notice how the relative warmth and coolness of the colors separate the birds from the background.

Juxtapose large and small shapes toward the foreground to give a suggestion of detail and provide extra interest.

STAGE 3
THE SEA AND ROCKS

■ The birds can now be tied more firmly to their environment by painting the sea. For this broad wash, use a mixture of Ultramarine Blue and Yellow Ochre with a touch of Light Red, loading the brush well and painting carefully but quickly around the birds so that the wash does not have time to dry before you finish. Bring in more light color on the ground, using a warm mixture of Light Red, Aureolin Yellow, and Cobalt Blue to get the sunny feel, and leaving white highlights to suggest the guano-spattered rocks.

TIP
Rough paper, as used for this painting, helps to encourage the effect of granulation, as it provides a series of little "wells" for the paint to lie in.

Leave small areas of white paper to indicate the flying birds, and when the main washes have dried, define the shapes by adding dark wingtips.

The granular texture of the paint adds interest to the wash. This granulation is partly caused by the volume of water and partly by the pigments used—Ultramarine Blue and Light Red both granulate naturally.

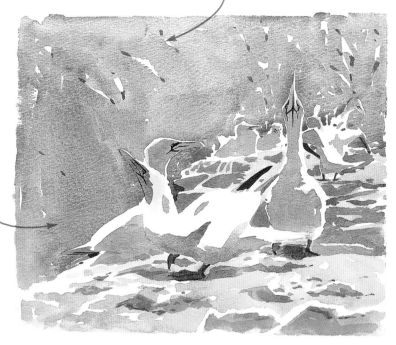

STAGE 4
FINISHING OFF

■ To finalize the sketch, give a second wash to the sea. This time, use diagonal strokes and leave occasional lines of the previous wash showing to suggest waves and give a directional emphasis that contrasts with the forms of the birds and rocks. Lay further washes on the rocks to build up the shadow effect and make the highlights appear stronger by contrast, but take care not to overwork, as the loose, free treatment is the essence of the sketch.

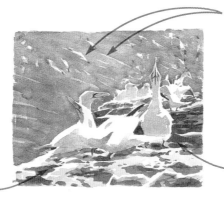

The diagonals of the flying birds and waves give a sense of movement that helps the eye to travel around the picture.

To give a sense of movement and bring in more variety of shapes and edges, lay smaller dark washes over the midtones.

The darker background accentuates the white of the plumage.

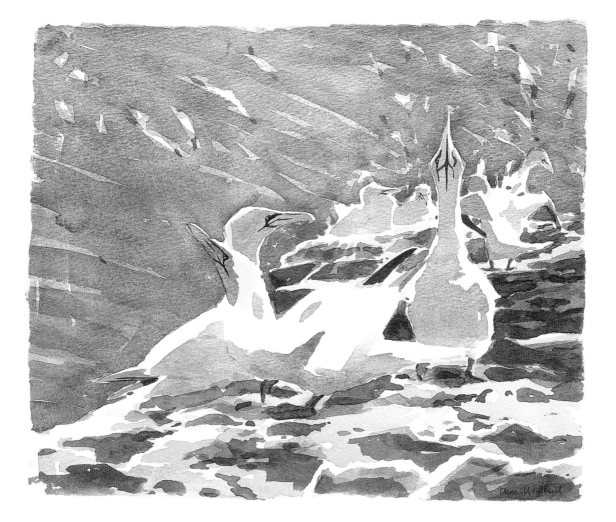

THE FUNDAMENTALS

Layout and composition

Choice of frame
Take the time to think about the type of frame you would like for your sketch—landscape or portrait—and the position of your subject(s) within it.

While making observation sketches of animals, you will begin to form ideas on how to develop them further into a complete picture, well balanced and pleasing to the eye. At this stage your drawings will start to take on a different function, and you will make an important step from note-taking toward artistic expression.

Negative shapes
To help you draw an animal correctly, look for the "negative" shapes between its limbs. These shapes are often simpler than the "positive" ones of the animal's body parts, and are a handy double-check when drawing.

Setting the boundaries

The first step in composition is to decide how to place your subject on the paper. Look at the animal's shape and posture and decide whether it will fit comfortably into the standard rectangular format, and if so whether it should be upright (portrait) or horizontal (landscape). Perhaps the drawing might be better placed in a square, or in a tall, thin upright—a giraffe or tall standing bird could be given emphasis in this way. If you find it difficult to decide on a satisfactory format, hold up a viewfinder to frame the subject; you can make one very simply by cutting a rectangular hole in a piece of card stock.

Positive and negative shapes

By giving borders for your sketch to lie within, you are deciding various forces of balance within a given shape.

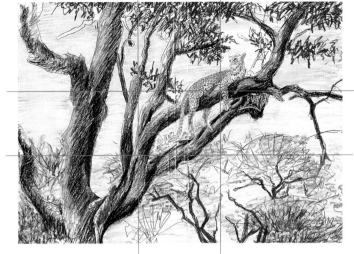

One of these is the balance of positive and negative shapes, which you can visualize by imagining the animal in silhouette. If you were to cut out this silhouette, you would be left with what artists describe as "negative space" or "negative shapes," which are the shapes around and between the "positive shapes," i.e., the animal and any separated parts of it, such as the limbs.

Achieving a balance between these two kinds of shape is important in compositional terms, but negative shapes also play an important role in accurate drawing, as you can use them to check whether the positive ones are correct. When drawing the four legs of a standing animal, for example, look carefully at the spaces between them. These shapes are easier to identify because not much is going on in the negative areas, whereas the positive shapes may confuse you with a wealth of detail.

The Golden Section *The so-called Golden Section, much used by Renaissance artists and architects, divides each of the sides of a rectangle into eight equal parts; intersections are placed at the points dividing a line into two lines in a ratio of 3:5.*

Guinea fowl
When drawing groups of animals, always begin by looking at the arrangement as one unit rather than a collection of disparate shapes and structures.

Placing focal points

Once you have decided on the format, which sets the boundaries for your drawing, consider the placing of the main elements in the composition. If your subject is a single animal or bird, it will be the focal point, but this does not mean you should place it right in the center. Excessive symmetry can be dull, because the eye is not led from one part of the picture to another. Setting up a sense of movement, where compositional elements are arranged irregularly and then counter-balanced with others, is vital in composition. So think about how you might balance the main shape with another one, or perhaps push it back in space to include more foreground or possibly some exciting shadow effects.

Focal point *The artist has opted for a landscape treatment for this sketch, with the lions to the right of center. The combination of these factors allows him to emphasize the lions' languorous posture, and their intimate relationship with their surroundings.*

Fallow deer

by David Boys

You will see a wealth of compositional possibilities when studying animals in their natural surroundings, and these fallow deer in parkland make an especially appealing subject. But deer are shy creatures, liable to run off when catching the scent of a human, so you will have to rely to a large extent on photographs and sketches, making a composite of these later in the studio. Be prepared to spend time on the preliminary studies—you can never have too much information—and pay as much attention to the landscape features as to the animals themselves Then, you can exploit the interaction of different shapes as well as the rich autumnal hues. In this colored-pencil drawing, the artist brings in a further element of contrast by using the solid, static masses of the tree trunks to emphasize the tension and delicate structures of the fighting deer in the foreground.

Practice points

- **WORKING FROM PHOTOS AND SKETCHES**
- **PLANNING THE COMPOSITION**
- **PLACING THE BACKGROUND SHAPES**

TAKING REFERENCE PHOTOS

A camera with a zoom or telephoto lens, mounted on a tripod if possible, will allow you to photograph the more distant deer. If you don't have this equipment, get as close as you can without alarming the animals. The landscape photographs can be taken at your leisure, but do make sure that the lighting conditions are the same as those for the deer.

MAKING VISUAL NOTES

■ Sketch the deer in as many different positions as possible, making color notes to provide additional information, as the colors in photographs are not always true or consistent from one photo to another. If you don't have time to do this, indicate the direction of the light by making a small cross in the margin of your sketch to avoid inconsistencies of lighting in the final composition.

EXPLORING POSSIBILITIES

■ The artist has provided himself with sufficient material to try out various groupings and arrangements. He decides to focus on the action between the two bucks for this drawing, though the other two sketches are equally satisfactory in terms of composition, and could be used on another occasion. Always keep your sketches so that you can refer to them again—one subject can provide material for several different treatments.

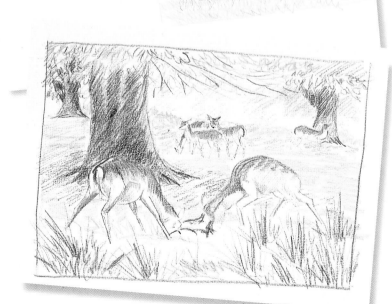

STAGE 1

DIVIDING THE SPACE

■ A horizontal format is chosen to emphasize the main action, and the shapes of the deer are drawn in to dominate the lower half of the picture space. The point of contact between the two bucks lies on a central vertical line, giving each an equal spatial area to emphasize the momentary deadlock in the ongoing test of strength.

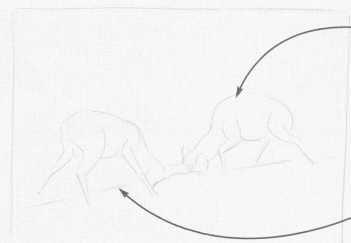

The artist is using an ocher-colored paper, which provides a key for the warm hues and allows him to draw in the light areas.

Draw in a directional axis line to note the angle at which the two deer are set. This will form the bottom of a rough triangle, with its apex near the top of the picture where the smaller group of animals are to be placed.

STAGE 2

PLACING THE BACKGROUND SHAPES

■ The large shapes of the tree-trunks need to be carefully placed within the boundaries. Again, bear in mind what artists call "the hidden triangle," which is an important compositional device. Here the arrangement between the tree trunks forms an upside-down triangle that the eye unconsciously follows to the main focal point, the headlock.

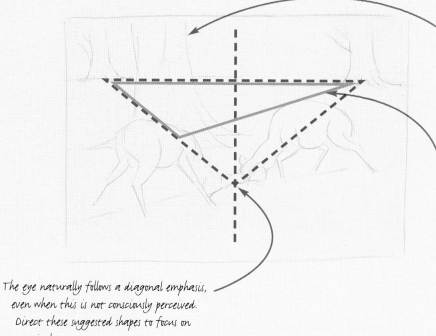

Use the strong vertical lines of the tree trunks to help emphasize the way the animals' legs are just as firmly rooted into the ground.

Look for patterns and shapes between the main structural elements of the landscape and use these to divide the space between the boundaries.

The eye naturally follows a diagonal emphasis, even when this is not consciously perceived. Direct these suggested shapes to focus on a particular area.

STAGE 3
ADDING SHAPES

■ You can now add the other elements of the composition—the foliage and background deer. Although these are subsidiary to the two main players in the drama, they are just as important, especially the line of deer acting as onlookers. These not only add background interest, but also strengthen the composition, as they are arranged along the back line of the suggested triangle between the tree trunks.

The leaves and branches give weight to the top of the picture, preventing the eye from traveling up the vertical lines and out of the picture.

The first triangle now begins to be more evident, with the directional axis line at the bottom and the small group of does at the top.

The angle of the fallen branch reinforces the directional axis line of the fighting bucks, and the bold fern shapes guide the eye up toward the main point of action.

The strongly defined angles of the hind legs guide the eye up through the trees to the small group of does in the background, which form another minor focal point.

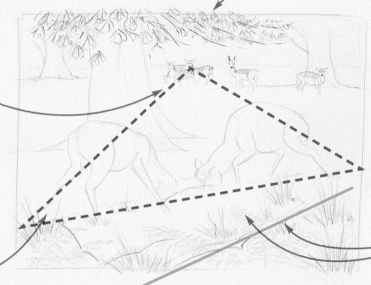

STAGE 4
PUTTING IN THE MAIN TONES

■ The tonal structure in a painting or colored drawing is just as important as the color itself. The solid tree trunks need to be shown as dark masses to emphasize the airiness and space between them, and the bucks require darker and lighter tones to build up the forms.

Use diagonal hatching for the tree trunks, keeping the strokes fairly open, as you will be building up the tones and colors gradually.

Reserve the strongest and warmest colors for the fighting bucks so that they dominate the foreground space.

Working on tinted paper allows you to add highlights with white, leaving the paper uncovered in places for midtones and lights.

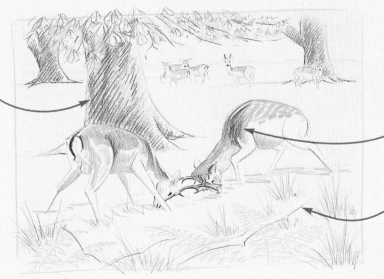

STAGE 5
BUILDING UP THE COLOR

■ So far, the drawing has been virtually monochrome, but you can now introduce some color contrasts to enliven the drawing and emphasize the dominant warm red-browns. Vary the pencil strokes to suggest the different textures, using a combination of hatching, short strokes, and linear outline.

You can suggest textures with blends of different marks and colors. Make the marks smaller in the background to create a perspective effect.

Apply a strip of bright green beneath the cool blue-grays to act as a horizon line, suggesting light and space beyond.

Use the colored pencils loosely and in different directions to suggest the surface planes of the ground.

STAGE 6
FINAL ADJUSTMENTS

■ The added colors have had the effect of partially dissolving the shapes and details in the foreground, so these now require reinforcement to bring them forward in space. The tree trunks also need strengthening, as does the foliage at the top of the picture, which provides a counterbalance to the foreground.

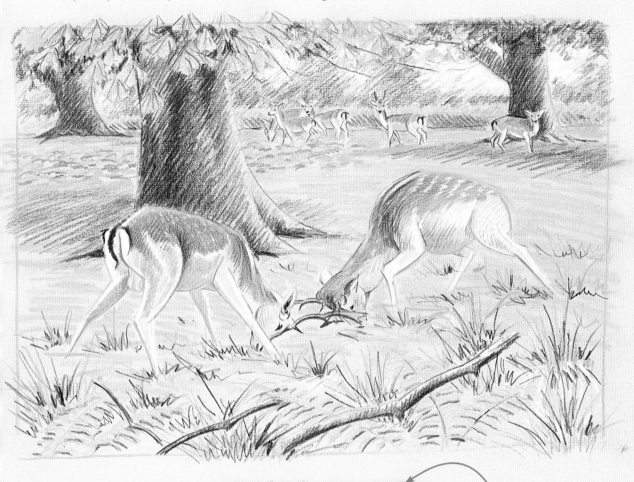

The bright yellows and greens bring these foliage details forward so that they stand out from the background. Again, echo these colors in the foreground to make a link.

Extend the tufts of grasses under the legs of the bucks to suggest the energy and tension that pushes them into the ground.

Use fairly dark greens to give weight to the foliage, but don't engage with detail, as this tree is much farther away than the main one behind the bucks.

Use similar purples and browns for both the tree trunks and the branches to create a color link between foreground and middle ground.

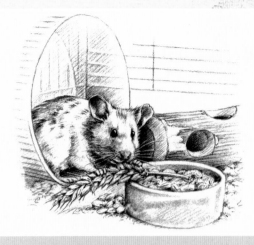

FOCUS on Animals

Once you have mastered the fundamentals, you may wish to concentrate on subject areas that are specific to animals—for example, Depicting Movement or Character and Personality. Simple step-by-step exercises show you how to perfect all those details that will set your sketch apart.

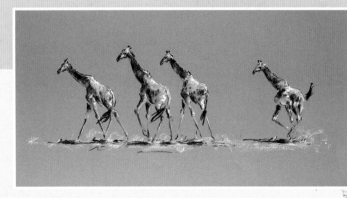

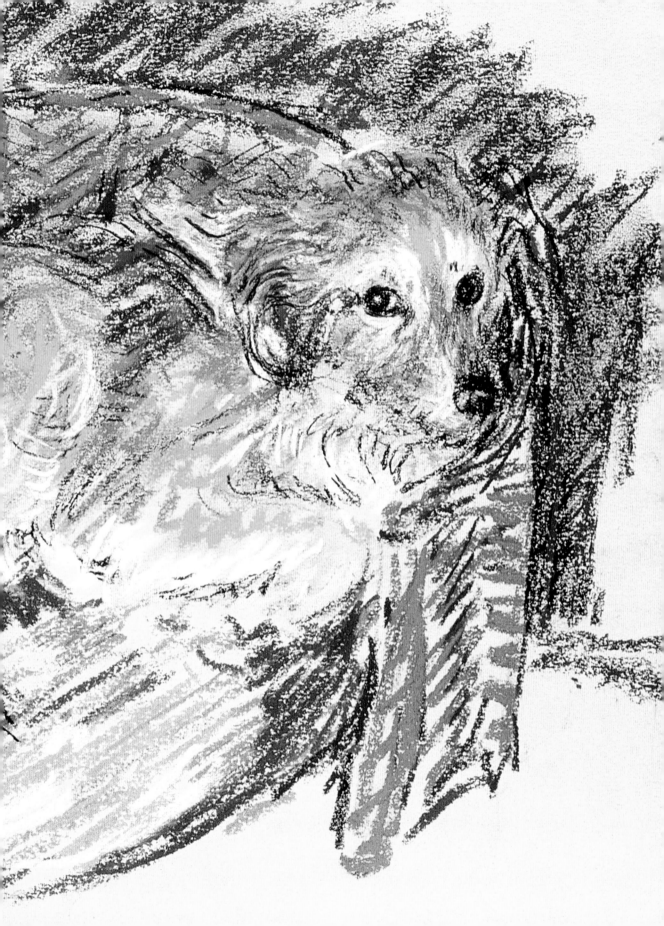

FOCUS ON ANIMALS

Depicting movement

There are two main factors involved in the study of moving subjects, the first being the self-imposed discipline that allows you to observe and record the movements. This is a practical skill, and will come with practice. The next important step is deciding how to use your drawing and painting media to convey the sense of movement on the page.

Observing sequences
By simply observing an animal in any given action you can note the regular sequences and patterns inherent in its movements.

Repeated movements

If you watch an animal, initially without putting pencil to paper, you will see that although the movements vary, there are regular patterns to them. You would seldom be able to identify these in the case of animals in the wild, which usually only provide fleeting glimpses, but they can be seen clearly in domestic or captive animals, which are confined in a certain space.

Training your memory

It is these repeated movements that allow you to take in extra information so that you can build up the same drawing over a period of time. This involves relying on memory to a large extent; with each new movement your mind must retain an image of the earlier ones. This may sound difficult, but memory plays such a natural part in our perceptions that you will quickly find that you can train your mind to retain enough of the image to put down its key elements. Observation is as important as drawing in this memory-training program, so spend as much time as you can watching characteristic movements. Once the animal moves on, close your eyes and retain the image in your mind's eye, then draw for as long as the memory lasts. You may find you can achieve remarkable results, especially when memory is combined with experience, an understanding of the creature's bonal structure (see pages 24–25) and a little artistic license.

Flight of grace
This eagle was captured at the key moments when it was landing and taking off. The shape of its huge wings— by turns curved and sweeping—denotes the nature of each dramatic movement.

Working quickly
If you want a medium that helps you draw fast, try ink (used with pen or brush), watercolor, or felt-tip pens. A large brush will allow you to cover a large area in one clean stroke.

Fast responses

You can also train yourself to respond very quickly to what you see, so that brain and hand work together almost simultaneously. Look at the subject, not at the page, and let your drawing hand follow the movement in fast, flowing lines that capture an essence of what is happening. Choose a medium that helps you to draw fast and does not offer the possibility of erasing, such as felt-tip pens, which slide rapidly over the paper surface, or brush and ink (or watercolor). A large squirrel brush holds a reservoir of ink or paint, allowing you to cover a large area without recharging the brush.

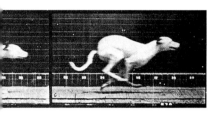

Working in the studio

If you are working from quick sketches, or perhaps photographs, toward a more finished drawing, try to get the same sense of movement into your work as you do when sketching. This is a slightly artificial exercise, as in this case you won't be working against time, but if your prime concern is expressing the sense of movement, pretend that you are, avoiding unnecessary detail and using your medium broadly and freely. You might find pastel or charcoal useful in this context, as both allow you to combine line with smudged passages, or you could try watercolor combined with pencil or charcoal pencil. Experiment as much as you can, always keeping the central idea of conveying movement foremost in your mind.

Studio work
Pastels and charcoal allow you to combine line with colored or shaded areas. This is useful if you are working from a photograph and trying to simulate movement in your sketch.

Swinging gibbon
The simple linear work of a felt-tip pen describes the gibbon's graceful action, while muscular form and structure are subtly implied with hatching and shades of gray.

Birds in flight
by Darren Woodhead

Drawing any moving subject is a test of memory and hand-eye co-ordination, especially in the case of flying birds, which constantly adjust their shape according to the invisible plane of the air. Start by finding subjects that are both accessible and numerous, so that you can be sure to have models always in front of you. Gulls are ideal, as they are not too quick in their movements, and are large enough and usually near enough for you to see them clearly. You will want a medium that allows you to work fast and helps to suggest movement. Pencil and watercolor, used for these sketches, are ideal for on-the-spot work, but keep the palette of colors as simple as possible.

Practice points
- LAYING WASHES OVER PENCIL
- VARYING THE LINE
- TRAINING YOUR MEMORY

OBSERVING AND LEARNING

■ Start by making preparatory sketches to get to know the subject, using a soft pencil (4B or 5B), which will move rapidly over the page and give strong lines. Draw bits of the birds—heads, tails, legs, and wings—seizing opportunities when the bird is still or preening itself. When you start to draw flight, concentrate first on the leading edge of the wing, as this is where the main energy and angles are. Try watching a bird in flight and then shutting your eyes so that you retain a snapshot-like image—a useful exercise in memory retention.

If the bird moves, leave your sketch and begin another. Don't try to finish every drawing, as a combination of completed and uncompleted drawings will add life and movement to your work.

Keep your drawings quick, trying to feel the sensation of flight and the planes of the air.

To give the subsequent washes a more sculptured look, add shadow and form with the pencil first.

Birds landing and taking off will often hold their wing position for a short while, giving you an opportunity to learn the wing angles.

Black-headed gull

STAGE 1
ATTENTION TO LINE QUALITIES

■ Once you have become familiar with your subject you can start taking your sketches farther. As you draw, think about the pencil line itself, and how you can use variations in the strength of line to suggest form. You can add a little plumage detail to support the shape and structure, but not too much, as this could have the effect of slowing the bird down; you can seldom see every detail as it swoops past you.

Use pencil shading only where it supports form, as in the case of these loose directional hatching strokes that indicate a flatter surface. These lines will show through the watercolor washes and reinforce them.

Note the variation in the strength of line, with heavier lines suggesting shadow and lighter ones the highlighted surfaces.

Keep all areas of brushwork simple to show the overall form of areas rather than individual feathers.

STAGE 2
LAYING WASHES

■ Once the pencil structure is in place, add washes over the pencil lines, working from light to dark. The washes will lightly fix the pencil drawing so that the lines don't smudge. A mixture of Light Red and Cobalt Blue gives a range of warm to cool colors and a convincing gray. Lay a gray wash over the wings, leaving the leading edge white, and when this is dry, add a slightly warmer hue to the shadows of the head and tail and build up the contrasts on the wings and tail band. Complete the sketch with touches of detail to the head and wing tips.

Make varied marks with the tip of a large brush to give a suggestion of the feathers, but avoid detail.

TIP
Use a much larger brush than you would normally choose, no less than a no. 8. This will hold more color and allow you to lay the washes more quickly.

Gannets hanging in the wind

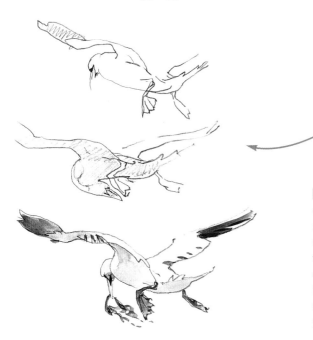

This page of sketches clearly shows
the build-up of knowledge.
A tentative, unfinished drawing
becomes one that explores tone,
finally developing into a confident
pencil-and-wash drawing.

CAPTURING MOVEMENT AND ENERGY

■ Seabird colonies are a must-paint subject for anyone wishing to capture the atmosphere of birds in flight. The sheer volume of the mass of birds and the interaction between individuals are fascinating. Gannets are large birds, and if the wind is in the right place, they will take turns to "hang" on air currents, making constant adjustments of wings and tail. Once again, spend time studying by sketching, identifying the important angles and keeping your pencil moving over the page. As a position changes, begin a new sketch so that you have a record of different movements and positions on one page.

Bring something to tie your sheets
down on exposed seabird cliffs. A simple
strong elastic band or a couple of large
clips will suffice.

Immature birds often have plumage
features that help to describe the form
and shape. Notice how the different forms
of the two birds—the one above flatter
and the one below more rounded—are
emphasized by the patterns.

The shadow on a white bird may reflect
surrounding colors. This can create unusual
effects, but put them in, as they are part
of the bird at that moment in time.

Kittiwakes

Keep all pencil shading to the minimum required to suggest form and tone. Notice the change in the weight of the lines in this sketch.

FEELING OF FLIGHT

■ Kittiwakes are especially rewarding subjects, as they have an attractive gentleness of expression and the ability to wheel around on updrafts while being characteristically vocal. You can't convey the sounds, but you can catch the movement. Any increase in breeze will provide the exciting sight of numerous birds performing, seemingly just for you. Think of your page as an expression of the movement, and try to imagine the feeling of flight over air. Remember to vary the line, but don't bring in unnecessary detail.

If a bird lands, seize this opportunity to study the wing angles. Foreshortening affects the shape considerably, as you can see if you compare this with the shape of the bird below.

Don't be afraid to include lines that you can't actually see, as these will enhance the feeling of a continuous form hidden below a surface.

TIP
A few extra colors are useful on occasions. Here the Cerulean Blue used for the sky contrasts with the Cobalt Blue used in mixtures for the bird, giving variety to the sketch.

Be aware of the action of the bird, and how it maintains its balance in the air. Here it is banking sharply to the left, with its head compensating for the shift of weight.

EXERCISE 15

Giraffes

by Julia Cassels

Giraffes walk silently and wonderfully sedately, dipping their long necks in rhythm with each stride. The fluidity of their gait is due to the fact that their legs on each side move in pairs rather than as opposites—the camel is the only other animal to walk in this way. But when giraffes run, with tails kicked out behind, the grace and fluidity are lost, and they look hilariously awkward, appearing rather like a ship tossing at sea. This exercise, with the first three giraffes walking slowly in a line and the fourth running to catch up, provides an exciting contrast of rhythm and counter-rhythm, while the play of light on the rich colors of the bodies brings in an additional element. The artist is working in pastels, the purest of all pigments—and ideal for capturing effects of light and color.

Practice points
• CONTRASTING DIFFERENT MOVEMENTS
• AVOIDING OVERWORKING
• WORKING OVER A TONAL DRAWING

PREPARATORY SKETCHES

■ Start with some rapid preparatory sketches to catch the essence of the moving animals, using a quick-to-use medium such as charcoal, pastel, pencil, or watercolor. You will often find you only have time to draw in the shadowed lines, but in the context of movement these are initially more important than the highlights.

Quick, bold charcoal marks describe the outline and suggest both the forms and the movement.

Using watercolor over pencil gives you a means of recording the colors as you saw them in a fleeting moment.

With pencil, you can be more precise, adding tone and a little detail with hatching lines.

STAGE 1

MAPPING OUT THE SHAPES

■ Start by making a charcoal drawing; this is easier to erase than pastel, and thus allows for corrections. Map out the shapes with the tip of the stick, using fluid lines and keeping the drawing as simple as possible. Notice how the artist uses just one line to indicate the legs.

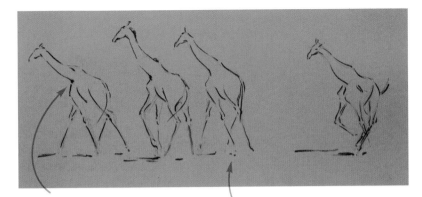

The slightly denser line here suggests shadow, indicating the direction of the light. It is important to establish this at an early stage.

The leg is deliberately left vague in order to convey the momentum of movement.

On the neck, chest and shoulder, you can apply the charcoal quite heavily. Leaving the highlights largely to the imagination gives the impression of a captured moment in the progression of movements.

Patches of near-black shadow on the underside of the belly emphasize the sweeping movement of the front and rear legs as they draw close together.

STAGE 2

BUILDING UP TONE AND ADDING COLOR

■ Block in the shadowed areas of the giraffes with the side of the charcoal stick. These help to convey the sense of movement, as the eye can only register the most obvious areas of light and shade, and shadows and highlights are constantly changing as the subject moves. Establishing the lights and darks first gives you a solid framework over which pastel color can now be added.

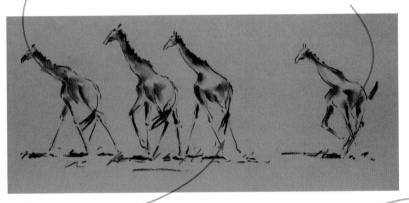

Highlights are often left until last in pastel work, but with a moving subject it is better to put them in earlier, as they act as a reminder as to the direction of the light.

The legs can be left almost untouched at this stage, as they are the part of the body most in movement.

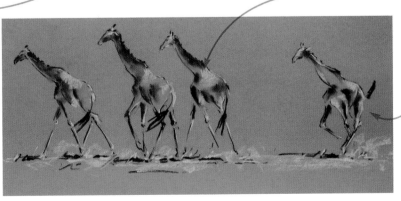

Notice how different areas of the giraffe are highlighted as it moves, changing the position of the limbs.

STAGE 3
BUILDING UP COLOR AND FORM
■ Continue to build up the colors and tones to give form to the giraffes. Take care not to overwork, however—leave areas of the paper unworked, and vary the pastel marks, using short strokes, twists, and scribbles to preserve the sketchy look that enhances the sense of movement.

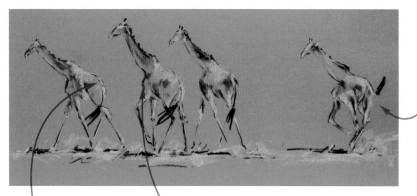

The separate areas of strongly blocked-in color slightly confuse the eye, replicating the viewer's perception of a fast-moving subject.

This area can be left uncovered with pastel, as the paper provides its own color.

As soon as a midtone color is added, the giraffe begins to assume substance and weight.

The tips of the pastel sticks quickly become blunted, so if you want precise lines, break a stick in half and draw with the sharp broken edge.

STAGE 4
CHARACTERISTIC FEATURES
■ The previous applications of color have begun to establish both forms and the characteristic markings. You can now add a little more detail, but again take care not to overwork. You can suggest most of the markings with two tones of pastel, and add cool blues to the heads, legs, and bellies to build up form.

Leaving areas unworked retains the sketchy quality that is vital in conveying the speed of the giraffe's movement.

A simple stroke of blue indicates the shadowed area while also giving an impression of the African heat, as shadows reflect color from the sky.

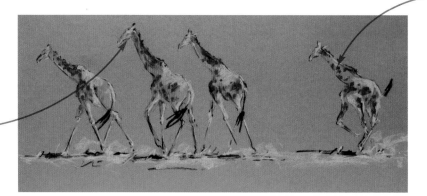

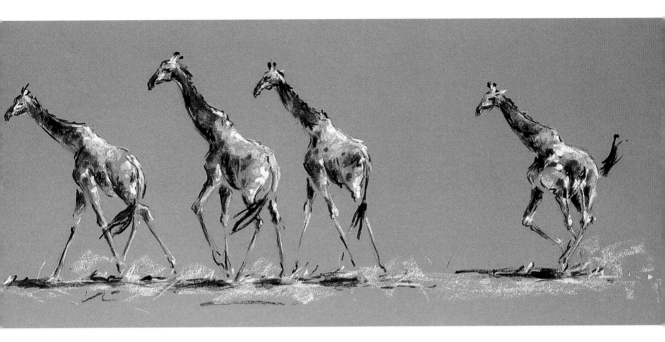

A touch of blue in front of the ear and some white along the cheekbone are all that is needed to place the eyes, horns, and muzzle.

Strong directional marks of white pastel emphasize the way the light bounces off the head, ears, back, and knees.

The cool green-blue over the warm yellows gives an impression of the strong, harsh sunlight.

The legs have been left undefined from the start, with most detail concentrated on the slower-moving body.

STAGE 5
COMPLETING THE DRAWING

■ At this stage, stand back from the work to assess it, and continue to do this for all the finishing stages. This will prevent you from overworking and ensure that you add color only where necessary. The artist adds some greenish-blue shadows to bring in a touch of complementary contrast (see page 51) and suggest the harsh light playing over the animals as they move. She sharpens the shadows on the running giraffe, but leaves physical detail and features deliberately vague to emphasize the movement.

FOCUS ON ANIMALS

Character and personality

Drawing anything from life forces you to look more closely than you normally would, and as you draw and observe animals you will begin to see individual characteristics emerging. This is very obvious in the case of domestic pets, as we know them so well, but there are also considerable differences between wild animals of the same species, while horse and ponies are as varied as the human race.

Facial expressions
A number of different sketches capture much more of this chimp's personality than any single sketch would.

Formal portraits
You can draw your pet in a particular context or against a plain background as done here. This Burmese cat was drawn in pastel pencil, an ideal medium for rendering the tactile texture of the cat's fur.

Animal portraits

These differences are not confined to variations in marking, coloration, and texture; animals have definite characters and personalities of their own, and a portrait should aim to show something of this. The strength of any portrait, whether of a person, a domestic pet, a well-known farm animal, or a favorite zoo creature, lies in capturing the essence of the character rather than in how well you depict the colors and textures of hair, fur, or feathers. In the same way, you can add interest and excitement to your sketches of animal groups by emphasizing each one's unique traits and seeing each one as an individual.

Working from photographs *If you wish to draw from photographs, try to take your own shots, so you will have spent some time acquainting yourself with the animals in question and will be able to determine the photograph's exact content.*

Domestic animals

If you want to draw or paint one of your own pets, you will be able to work from life, and decide what other "props" to include. But animal portraits are becoming increasingly popular, and you may be commissioned by someone else to make a portrait of a cat, dog, horse, or pony, which would probably involve working from photographs. If possible, it is best to visit the animal and take your own photographs, making sketches as well if time permits, and spending time observing the subject. Working from other people's photos can be frustrating, as they may not bring out the animal's

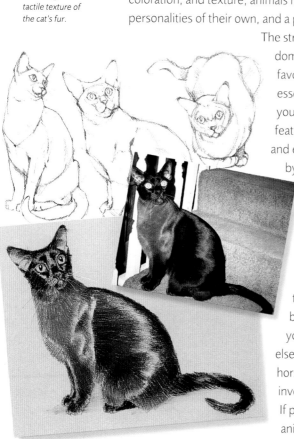

character or include any of its natural setting. As in human portraits, the setting can be important, as it tells a more complete story about the subject.

Age and body language

When observing animals, whether on farmland, in the wild, or at the zoo, you will see many different features that distinguish one from another. Age is one factor, with the younger ones being sprightly and full of energy, and the older creatures slower and more languid, sometimes with a hunched appearance. Coloration and markings of coat or plumage can also define the age of an animal, because in some cases there are differences between juveniles and adults. Facial expressions are rare in the animal kingdom except for some monkeys and apes, but body language is an important factor in analyzing character, as it is a vital form of communication among individual animals. An animal might be holding a particular stance or behaving in a certain way for a variety of reasons, such as asserting its authority, attracting a mate, or simply being alert to danger.

Mature silverback
These preliminary sketches of a mature-gorilla depict much of its meditative character.

Young and old
Your knowledge of an animal's body structure and personality can be greatly enhanced when you compare and contrast different age groups and observe how they interact with one another.

Human and animal interactions

Domestic and farm animals will take little or no notice of you drawing them, but if you are working at a zoo, bear in mind that your own body language can affect the animals' behavior. Some become very agitated when watched for any length of time, and gorillas dislike face-on confrontation, regarding eye-to-eye contact as a serious threat. To avoid upsetting your models, you will need to acquire the knack of standing facing to one side, drawing from the "corners" of your eyes.

On the farm *Most farm animals are quite placid and will take little or no notice of you as you sketch them.*

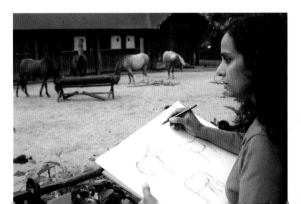

EXERCISE 16

Portrait of a pet dog
by Kay Gallwey

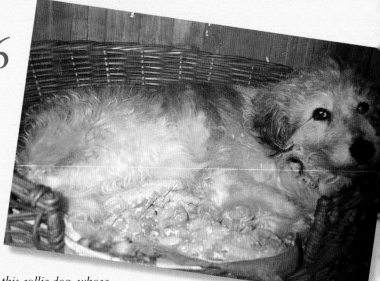

Using your own pet as a model has two major advantages over drawing creatures in the wild or in a zoo. First, you will be familiar with the animal's moods and expressions, and second, you will have a better understanding of the underlying forms. We all stroke our dogs and cats, and this is an excellent way of getting to know the bone and muscle structures. Learning by touch is especially important in the case of long-haired animals such as this collie dog, whose mass of hair hides the slender bone structure of a greyhound. Build up your knowledge by sketching as often as possible; it is a good idea to keep small pads and pencils in various places around the house. The artist made countless sketches and studies of her dog, Clarence, in his lifetime, and is using them as a basis for this pastel drawing.

> **Practice points**
> * LEARNING FORM BY TOUCH
> * INDENTIFYING CHARACTERISTICS
> * PLANNING THE COMPOSITION

PRELIMINARY SKETCHES

■ Start with some preliminary sketches to explore various possibilities and plan the composition. You can use any inexpensive drawing paper for these.

Now try out different formats. Don't waste time on detail, just sketch out different shapes and fit the animal into them.

Use soft pencil to sketch the main outline and suggest the texture and direction of the hair. The big ruff is a characteristic feature of collies.

Make a final quick pencil sketch of the composition. The artist has decided on this one, in which the shape of the dog is framed by the basket, and thus requires little background.

Before starting on the final picture, make some sketches of details—eyes, nose, tail, and so on. Clarence had very expressive eyes, and one of his characteristics was to show the whites, giving him an almost human appearance.

STAGE 1
STARTING THE DRAWING

■ Choose a paper color that blends with the subject, allowing you to leave areas uncovered without creating a jumpy effect. Here a warm beige is used, and will be left as the lighter areas of the dog's coat.

suggest the shaggy coat by breaking the outline with lines of hatching.

Draw the eyes as simple shapes, but make sure they follow the angle of the head.

TIP
Use either pastel or charcoal for the underdrawing. Pencil is less suitable, as graphite is slightly greasy and tends to repel the pastel colors.

Lightly sketch the composition, using a midtone warm brown, which is the most dominant color in the picture.

STAGE 2
ESTABLISHING THE MIDTONES

■ Now begin to build up the drawing, adding more midtones and light tones, indicating the main darks, but still working lightly. Don't rub or blend any colors at this stage; instead keep the strokes open, and vary them to suggest the texture and direction of the dog's coat.

TIP
Avoid using black pastel for the underdrawing unless the picture is to be very dark in tone. When you blend colors they will become gray and dirty if there is black beneath them.

Make broad, light strokes with the side of a short length of pastel.

suggest the underlying forms by varying the direction of the pastel marks.

Use white pastel for the palest areas of the coat.

STAGE 3
BUILDING UP THE COLORS

■ When you are satisfied that the composition is well balanced and the proportions are correct, you can begin to add more colors and to blend lightly in certain areas. The artist has decided to introduce blues into the foreground to contrast with the warm red-browns.

TIP
Always blend with a clean finger, or you will muddy the colors. Pastels dirty your hands very quickly, so keep a damp rag and some paper towels on hand so that you can clean and dry your hands when necessary.

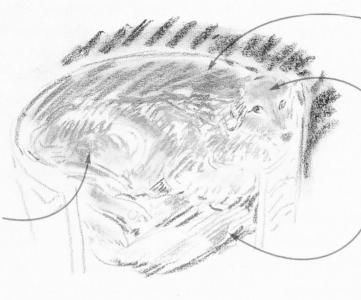

Use shades of brown and rust for the basket, blending them together lightly with your finger.

Add more yellow and orange here and blend to indicate the smoothness of the head hair, which contrasts with the shaggy body coat.

Lay light side strokes of orange and yellow over the original lines, and blend very gently.

Lay down stripes of dark and light blue for the blanket, and leave them unblended to create foreground interest.

STAGE 4
MIXING THE COLOR ON THE PAPER

■ Keep building up the colors and tones to achieve a sense of depth, and darken the background behind the basket, but don't overdo the blending, or the picture will become dull and bland. As far as possible, mix colors on the paper surface by laying down strokes of orange, red, and yellow next to one another. This make the colors "bounce," and keeps them clear and bright.

Darken the background with more strokes of dark gray and blue-gray, blending lightly to make this area recede in space.

Dark shadows add depth to the image and help to describe the forms.

Draw the main lines of the wicker basket with red-brown pastel and then overlay lines of darker brown and black.

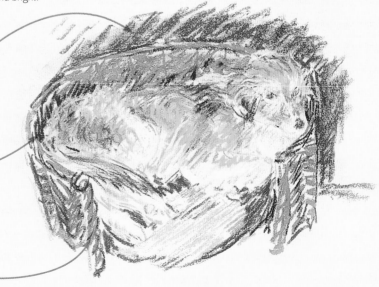

STAGE 5
THE DETAILS

■ Now you have reached the final and most rewarding stage, when you can add the details that give the animal its special character. If you have used very soft pastels, as the artist has, your drawing will need to be sprayed with fixative before continuing (open a window first if possible). To complete the portrait, use a dark brown or black Conté crayon to pick out the details, darkening and intensifying the eyes, nose, ears, and paws. Finally, pick out the highlights—such as those in the eyes and on the wet nose—with a clean white pastel or Conté crayon, and add a few more details to the coat and basket if necessary.

Work on the basket with black Conté to bring the picture together and emphasize the curve of the dog's hindquarters.

Draw the fine hairs of the whiskery coat with black Conté, and describe the tail with long, sweeping strokes.

The shiny eyes and nose make an attractive contrast with the rough textures of the coat and basket and also make the dog appear bright and alert.

Define the face more strongly, as this is the focal point of the composition. Use dark brown pastel to show the shadow cast by the basket.

EXERCISE 17

Portrait of a pet hamster
by Bridget Dowty

Making a study of an individual animal requires careful observation over a period of time. This makes a pet an ideal subject, as you will be familiar with its physical appearance, its characteristic expressions, mannerisms, and behavior, and the way these change with its moods. You will also have the advantage of being able to use a combination of photographs, sketches, and simple observation to work up the final drawing, as the artist does here. Don't be too reliant on photos, however, as drawing is a much more effective way of learning the subject and being more flexible, allowing you to choose the elements of your composition to show just what you want about the animal.

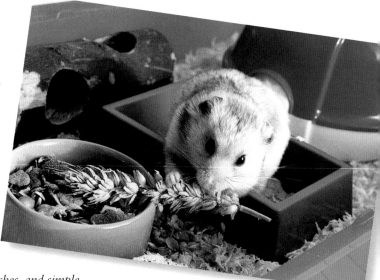

Practice points
- WORKING FROM PHOTOGRAPHS AND SKETCHES
- COMPOSING THE DRAWING
- EXPRESSING CHARACTER

PREPARATORY SKETCHES

■ Sketching helps you to study the animal in depth, and also to work out how you can translate your observations to marks on the page. Sketch from a good variety of angles so that you can see how the appearance of the animal changes from different viewpoints. The more you draw, the more possibilities you will see, and the final drawing will begin to take shape in your mind.

For preliminary sketches and the initial stages of a final drawing, the artist favors a propelling pencil with HB or B leads. This allows you to work quickly and freely without constantly needing to reach for a pencil-sharpener.

The big ears of this hamster, whose name is Mouse, change his appearance significantly, being flattened when he is sleepy and raised when he is awake and alert.

Note how the position of the features alters depending on the angle of viewing, and how this affects the character of the face.

In a furry animal like a hamster, loose shading helps to indicate the body structure beneath the thick coat.

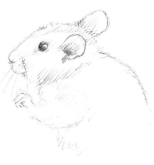

To help you to draw the wheel, mark a central vertical line as a guide, and complete the whole curve to check that the shape is correctly balanced.

You don't want detail at this stage, but accuracy is vital, so be precise with the proportions and any typical poses. Note the position of the features in relation to each other as this is essential to character.

The bars of the back of the cage can be drawn quite loosely, and those at the front omitted, giving the impression that we are in the cage with the animal.

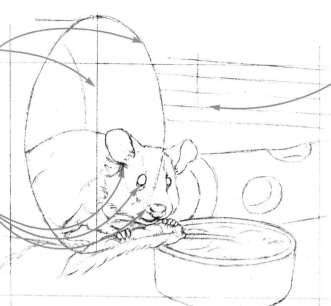

STAGE 1
STARTING THE DRAWING

■ The artist wanted a characteristic wide-awake pose and a setting that would help focus the eye on the hamster, so she chose to combine aspects of three photographs. When deciding on the composition, think about the positioning of all the elements, as well as how the tones will work together. For example, the dark hollow of the log behind Mouse's head will nicely offset the pale side of his face.

STAGE 2
ADDING SHADING AND DETAIL

■ Once you are happy with the "skeleton" of the drawing, you can erase any guidelines and much of the outside frame. If you erase at a later stage you could remove important parts of the drawing. Make some loose lines of shading to indicate the light source and give more depth to the drawing. You can also pencil in any important details that make the study more personal.

Keep the wheel and bars in the background very simple—they should not be too prominent.

Detail on the wheat helps the viewer to focus in on Mouse.

Blocking in some tone shows how the face catches the light. Once you have established the light source it is vital to stick to it throughout the drawing.

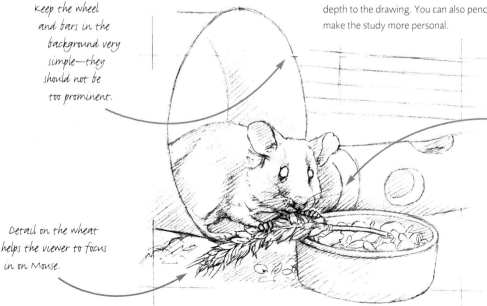

STAGE 3
CHARACTER AND TEXTURE

■ The eyes are the natural focal point of any portrait, and as soon as you render shade and add highlights, the subject comes to life. It is important to look closely, not only at the eye itself but also the rim and surrounding fur, as the detail here lends expression to the whole face. You can change to a traditional B pencil at this stage, as the softer lead gives a stronger mark and allows for more varied shading.

Increase the strength of the shading where greater depth of tone is required. Also pick out more detail, such as the light on the fur and the form of the ears.

Varied directional pencil marks give a simple but effective representation of different textures.

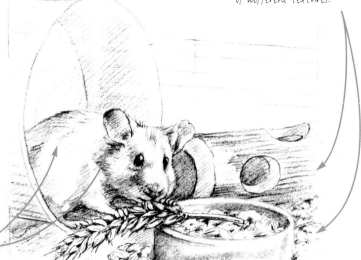

Create strong highlights and carefully smudge the shading to gain the effect of the bowl's shiny, glazed surface.

TIP

Pull your putty erasers into a point to lift out small areas very precisely.

TIP

A B or 2B pencil allows you to build up a range of tones and textures by varying the pressure and direction of the stroke.

STAGE 4
FOCUS ON DETAIL

■ Continue to build up the textures and tones gradually, using shading to enhance detail. For example, deepening the shadow at the end of the log provides the opportunity to highlight the pale tufty fur of Mouse's face. When drawing the fur, make short, soft pencil strokes to contrast with smoother, glossier textures of the nose and eyes. Keep checking the drawing, and don't be afraid to make alterations.

The small darker patches of fur around the eye enhance the alert look and convey vulnerability.

A putty eraser is used to lift out some of the shading, giving the impression of the cage bars seen through the transparent wheel.

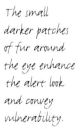

Draw the whiskers briskly with a very sharp soft pencil, such as a 4B pencil.

Both the shadow behind Mouse's body and the fine highlights on his back and the tip of his ear make him stand out against the background.

Only a light suggestion of the wheel and cage is needed to establish the setting.

To pick out the sparkle in the eyes and the finest points of the ears and whiskers, you can touch in white gouache or watercolor with a fine brush, but use the paint very sparingly indeed.

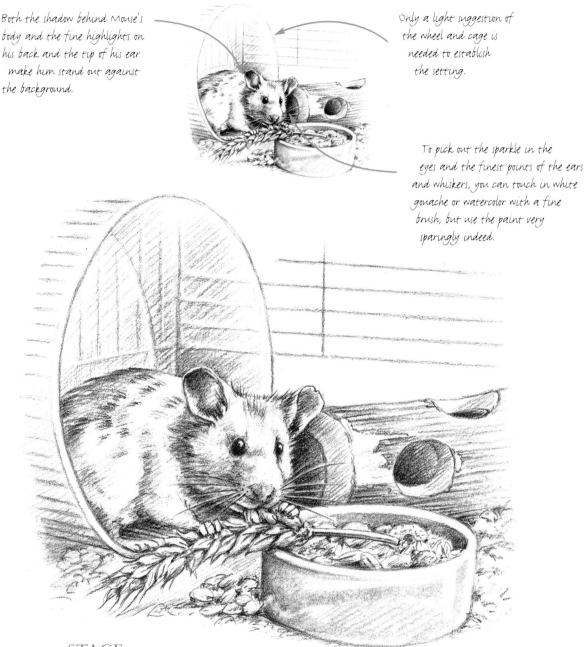

STAGE 5
COMPLETING THE DRAWING

■ Now that the drawing is nearly finished, take some time to re-assess it. The artist had originally intended to crop the drawing so that it fitted within the original frame, but now decides that she likes the loose vignette effect, with the whole of the wheel sketched in. She makes a few finishing touches, adding highlights and enhancing the shadows and darkest detail with a sharp 4B pencil. She also draws in the whiskers that cross shadow or dark fur, and thus appear light, with the putty eraser. She also uses the putty eraser to clean up the highlights on the food bowl, fur, and corn, because graphite can spread slightly in the course of a drawing, dulling the lightest areas.

Mediums Technique Directory

Dry mediums like wooden and carbon pencils, charcoal, soft and hard pastels, and colored pencils are flexible tools for drawing and sketching. But wet mediums such as inks, oil pastels, and watercolors present sketchers with an equally wide and expressive range of techniques.

WOODEN PENCIL

Wet your finger with a little bit of clear water and use it to smudge water-soluble graphite to create tonal areas. Here, the graphite has been blended on a panda's coat.

A wooden pencil is a graphite strip sealed in a wooden case. It can be used on a variety of different surfaces to produce a wide range of linear effects. Note the difference between the lines made with a B (hard), a 3B, and a 6B (soft) pencil (left to right).

GRAPHITE STICK

Graphite sticks are short lengths of graphite with a square, rectangular, or round profile. They are sharpened to a point at one end. Longer, thinner sticks, the same size and shape as a traditional pencil, are also available. They can be used, as shown here, to create large areas of tone.

You can use an eraser to lift out areas of tone and create a variety of desired effects, including natural markings, texture, or highlights on an animal's body. Knead the eraser into a point for small details.

Lines can be hatched or crosshatched with a wooden pencil to build up areas of varying tone and density. Pressure, speed of application, and the pencil grade all have an impact on the final result. Here part of an animal's body is crosshatched to show that it is partly in shade.

Tone can be lightened by blending an area of tone with a finger.

CARBON PENCIL

A carbon pencil is compressed charcoal sealed into a wooden case. It is a soft pencil that gives a rich black line with very little pressure. Used on damp paper, it yields an even denser, velvety black line.

CHARCOAL STICK

Charcoal responds well to fluid drawing movements and pressure variations. Thin charcoal sticks produce expressive linear strokes, such as hatched lines or marks.

Areas of tone and texture can be quickly scribbled in with wide strokes, using the edge of the stick.

You can use your finger to blend different areas of tone together to simulate the textures and gradations seen on an animal's hide or furry exterior.

You can build up large midtone areas quickly and easily by using a large charcoal stick on its side.

CHARCOAL PENCIL

Wooden charcoal pencils contain thin strips of compressed charcoal, and are found in grades of soft, medium, and hard. They are less messy to use than stick charcoal and can produce finer lines, which can be used to delineate close detail such as an animal's features and facial expression.

Use an eraser to work back into your work and create highlights and interesting textural qualities.

Drawing paper and pads

The major manufacturers produce paper in both sheet and pad form, the latter being available in a wide range of sizes. Smooth drawing paper, in light-, medium-, or heavy-weight form, is widely used for drawing with dry mediums and ink. Special papers are available for water-color and pastel work.

SOFT PASTEL

Soft pastels are the most commonly used pastels and offer the widest choice of tints and tones. Using the sharp edge of a pastel gives fine lines that can be used for hatching and crosshatching.

Side strokes can be used to lay in broad, sweeping areas of solid color, or to scumble one color over another. Applying the pastel with varying pressure results in more or less pigment being transferred to the paper.

Areas of color can be built up quickly by blending with your finger. Pastels mix well with other drawing mediums, including colored pencil, watercolor, and gouache.

Build up layers of color using different pastel colors of varying intensity. Here, layering is used to describe the fine details of a lion's mane.

HARD PASTEL

Hard pastels are usually square, but can be sharpened to a point with a sharp craft knife. You can use the end or sharp edge of the pastel to create the huge variety of lines, markings, and dots that you see on animals.

The powdery quality of pastel makes it possible to blend two or more colors together. Here a green pastel is used to block in a large area of color before yellow is laid on top for a glazed effect.

CONTÉ STICKS/PENCILS

Conté sticks are similar to hard pastels and are available in a range of traditional colors, including black, white, sanguine, sepia, and bister. Use a Conté stick on its side to produce blocks of solid color.

Pastel sheets and pads

Most pastel artists will use specially textured pastel papers that will hold several layers of dry pastel dust without becoming saturated. Pastel papers are available in a wide range of colors.

Using fixative

Fixative leaves a matte layer of resin that coats and holds any loose pigment dust in place. It is usually used with charcoal and pastel sketches. Fixative is available in aerosol cans, and in bottles that use a pump action or need a diffuser, and should always be sprayed away from the face and clothing.

A Conté pencil produces finer lines than those of a Conté stick, suitable for drawing small details.

WAX CRAYON

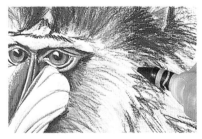

Wax crayons mix well with other mediums, especially colored pencils as shown here. The crayons can be used to color in detail or large areas of color.

OIL PASTELS

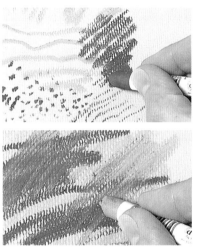

Oil pastels can be opaque, semi-transparent, or transparent, and a strong range of colors is available in this medium. They can be used to make different textural marks and layered one on top of the other, as shown here.

The consistency of oil pastels is perfect for creating effects with sgraffito, or scratching techniques, using a craft knife.

PASTEL PENCIL

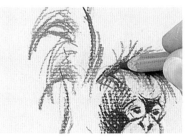

Pastel pencils are made of a strip of hard pastel secured inside a wooden case. They are ideal for linework, especially when working detail into a sketch made with soft or hard pencils. Sharpen pastel pencils with an ordinary pencil sharpener or a craft knife.

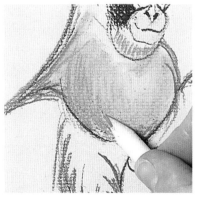

You can use a tortillion instead of your finger to blend in areas of color, depending on the effect you wish to achieve. A tortillion can be used with most soft mediums and has a more precise edge than a finger.

COLOR PENCIL

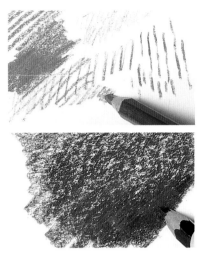

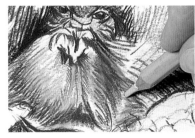

Colored pencils are quick and clean to use, and are easy to transport. All the traditional line techniques and marks that are possible with graphite pencils, such as hatching, can also be made using colored pencils. Colored pencils can also be used to color in large areas.

Colored pencils can be mixed on a paper's surface. Seen from a distance, two colors that are closely hatched will appear as a solid blend of the two colors.

WATER-SOLUBLE COLOR PENCIL

Water-soluble colored pencils are a cross between colored pencils and watercolor paints. You can apply the color as you would with a colored pencil and then use a soft watercolor brush dipped in a little water to dissolve the pigment and blend the colors together on the paper surface.

By wetting your finger with just a little water, you can blend different areas of water-soluble colored pencil together, describing, as shown here, the soft, downy texture of a bird's plumage.

ART PEN

Art pens resemble traditional fountain pens. Different-sized and -shaped nibs can be used to draw fine lines, curves, and dots.

Art pens are ideal sketching tools as they can be used quickly. An art pen can be used for hatching, suggesting form and tone, while the precision control of the pen nib is useful for the finer details of eyes, nose, and mouth.

Once you have sketched the main outline of your animal subject with an art pen, you can fill larger areas with washes of color.

Watercolor pads

Watercolor paper can be bought in separate sheets or in pads. Cold-pressed watercolor paper is widely considered to be the most versatile and easy to use.

BALLPOINT PEN

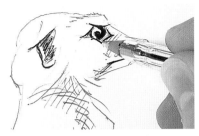

Although ballpoint pens produce lines of a uniform width, they can be used to emphasize fine detail as well as create lively and spontaneous effects.

BRUSH PEN

Easy to use, brush pens have a flexible, brush-like nylon tip which allows them to make the kind of fluid and gentle strokes shown here.

MARKER AND FELT-TIP PENS

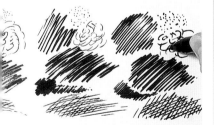

Marker and felt-tip pens are available in a wide range of colors, nib thicknesses, and shapes. Here, black pens with nibs ranging from fine to thick have been used to create various markings.

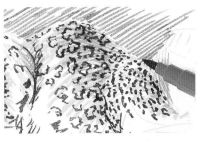

You can use colored markers and felt-tip pens to create blocks of color or to mix colors on the paper surface.

You can create interesting effects by working into felt-tip or marker drawings with water.

INK

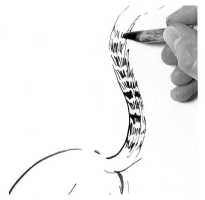

Bamboo pens are cut from a short length of bamboo and vary in thickness. Some are shaped in such a way as to give a different-sized nib at each end. Here, a bamboo pen has been used with water-resistant ink to draw fine lines, suggesting the furry quality of a cat's tail.

If water-resistant ink is used, as here, tonal washes can be applied to linework.

Used here over a dry wash of yellow ink, a brush loaded with orange ink can be used to sketch in snatches of detail.

Dip pens consist of a holder which can be used with a selection of nibs. They produce flowing lines of varying widths, depending on the pressure you put on the nib. If you sketch a subject using water-soluble ink, you can then use a brush dipped in clear water to blend in areas of tone as shown here.

WATERCOLOR

To lay a flat wash, load a large wash brush with paint and, starting at the top, make a steady horizontal stroke across the paper. The next stroke will need to overlap the first slightly.

You can add wet paint to a layer of paint that has already dried, a technique known as wet-on-dry. This allows you to darken areas of color. Try to lay each new layer of color quickly and with the minimum of brushwork.

Once the masking fluid is dry, it can be freely painted over as it acts as a block to the paint.

Apply wet paint to an area that is already wet with paint, a technique known as wet-in-wet. Depending on how wet the base layer is, the technique results in colors flowing and blending together.

Intricate highlights such as these hairlines on a monkey's head are awkward to paint around, so the best method is to reserve them with masking fluid before painting. Brush the fluid onto the areas of the work that you wish to reserve.

Stretching paper

Most paper will swell and buckle if it is wet. When working with wet mediums, such as watercolor, stretch the paper in advance to avoid ruining your work.

1 Place your paper on a large board.

2 Measure and cut pieces of adhesive paper tape to fit around the edges of the paper. Don't use the adhesive just yet.

Watercolor paper

Watercolor paper is woven, acid-free, and usually white. It comes in degrees of thickness and in three different textures: rough, cold-pressed, and hot-pressed. Machine-made papers are the least expensive, but may distort when wet. Mouldmade papers are less resistant to distortion. The best, but most expensive, types of watercolor paper are handmade.

When you paint over the surface, the color will slide off the waxed areas and into the paper grain, creating this wonderfully speckled effect.

When the paint has dried, the masking can be removed by gently rubbing with a finger or soft eraser to reveal clean, white paper.

Wax resist, which can be candlewax, oil pastel, or wax crayon, also blocks paint, but less completely than masking fluid, so it can be used to produce interesting effects. First, lightly draw or scribble with a candle.

Fine white lines can be created by scratching color away with a blade to reveal the white paper beneath. Let the painted surface dry completely, then use the point of the knife to scratch into it. This a useful technique for creating highlights.

3 Dampen the sheet of paper in a tray of clean water.

4 Lay the paper on the board. Dampen the strips of paper tape and lay a strip along each edge of the paper, with one-third of the tape covering the paper and the rest covering the board.

5 Smooth the surface of the tape down with a sponge. Gently wipe excess water from the paper and leave to dry until the paper is taut. Remove the paper from the board by cutting away the tape with a craft knife.

Suppliers

Many of the materials used in this book can be purchased at good art supply stores. Alternatively, the suppliers listed below can direct you to the retailer nearest you.

NORTH AMERICA

Asel Art Supply
2701 Cedar Springs
Dallas, TX 75201
Toll Free 888-ASELART (for outside
 Dallas only)
Tel (214) 871-2425
Fax (214) 871-0007
www.aselart.com

Cheap Joe's Art Stuff
374 Industrial Park Drive
Boone, NC 28607
Toll Free 800-227-2788
Fax 800-257-0874
www.cjas.com

Daler-Rowney USA
4 Corporate Drive
Cranbury, NJ 08512-9584
Tel (609) 655-5252
Fax (609) 655-5852
www.daler-rowney.com

Daniel Smith
P.O. Box 84268
Seattle, WA 98124-5568
Toll Free 800-238-4065
www.danielsmith.com

Dick Blick Art Materials
P.O. Box 1267
Galesburg, IL 61402-1267
Toll Free 800-828-4548
Fax 800-621-8293
www.dickblick.com

Flax Art & Design
240 Valley Drive
Brisbane, CA 94005-1206
Toll Free 800-343-3529
Fax 800-352-9123
www.flaxart.com

Grumbacher Inc.
2711 Washington Blvd.
Bellwood, IL 60104
Toll Free 800-323-0749
Fax (708) 649-3463
www.sanfordcorp.com/grumbacher

Hobby Lobby
More than 90 retail locations throughout the US. Check the yellow pages or the website for the location nearest you.
www.hobbylobby.com

New York Central Art Supply
62 Third Avenue
New York, NY 10003
Toll Free 800-950-6111
Fax (212) 475-2513
www.nycentralart.com

Pentel of America, Ltd.
2805 Torrance Street
Torrance, CA 90509
Toll Free 800-231-7856
Tel (310) 320-3831
Fax (310) 533-0697
www.pentel.com

Winsor & Newton Inc.
PO Box 1396
Piscataway, NY 08855
Toll Free 800-445-4278
Fax (732) 562-0940
www.winsornewton.com

UNITED KINGDOM

Berol Ltd.
Oldmeadow Road
King's Lynn
Norfolk PE30 4JR
Tel 01553 761221
Fax 01553 766534
www.berol.com

Daler-Rowney
P.O. Box 10
Bracknell, Berks R612 8ST
Tel 01344 424621
Fax 01344 860746
www.daler-rowney.com

Pentel Ltd.
Hunts Rise
South Marston Park
Swindon, Wilts SN3 4TW
Tel 01793 823333
Fax 01793 820011
www.pentel.co.uk

The John Jones Art Centre Ltd.
The Art Materials Shop
4 Morris Place
Stroud Green Road
London N4 3JG
Tel 020 7281 5439
Fax 020 7281 5956
www.johnjones.co.uk

Winsor & Newton
Whitefriars Avenue
Wealdstone, Harrow
Middx HA3 5RH
Tel 020 8427 4343
Fax 020 8863 7177
www.winsornewton.com

Index

Credits

Quarto would like to thank and acknowledge the following for permission to reproduce the pictures that appear in this book.

Key: b=bottom, t=top, c=center, l=left, r=right
David Boys 3, 10b, 11c, 25b, 35b, 50c/cr, 73t, 83br, 92tr, 93c; **John Busby** 68t, 84t; **Julia Cassels** 61 b, 82bl; **Penny Cobb** 34 tr; **Bridget Dowty** 60br; **Victoria Edwards** 24br, 25 tr; **Ruth Geldard** 112; **Sandra Fernandez** 7b, 11t; **Kay Gallwey** 60bl; **Stephanie Manchipp** 92l; **Nick Pollard** 24bl, 73b; **Mary Ann Rogers** 51t, 72/73bc

All other photographs and illustrations are the copyright of Quarto Publishing plc. While every effort has been made to credit contributors, we would like to apologize in advance if there have been any omissions or errors.

Quarto would also like to thank the London Zoological Society for kindly permitting the photographer and artists to photograph and sketch the animals in London Zoo.